THE ART OF FOOD

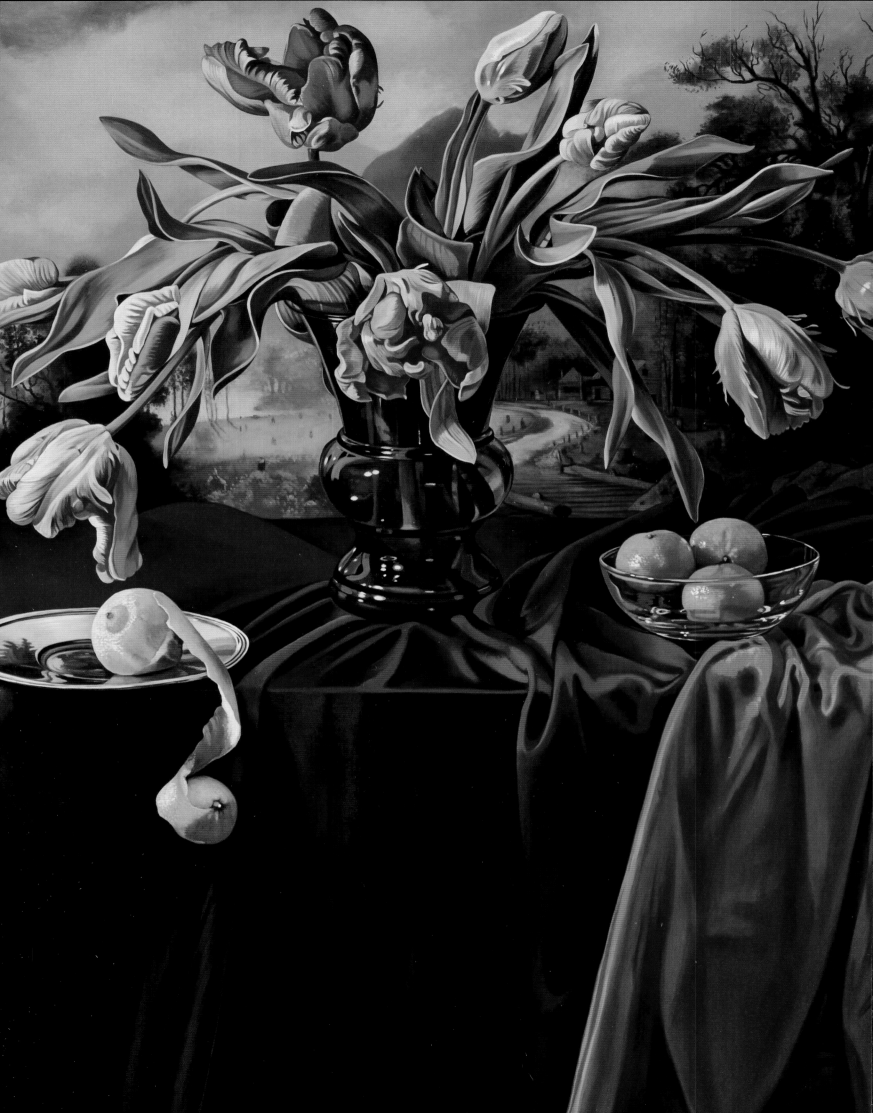

THE ART OF FOOD
EL ARTE DE LA COMIDA

FROM THE COLLECTIONS OF JORDAN D. SCHNITZER AND HIS FAMILY FOUNDATION

The University of Arizona Museum of Art, Tucson, Arizona
Jordan Schnitzer Family Foundation

CONTENTS

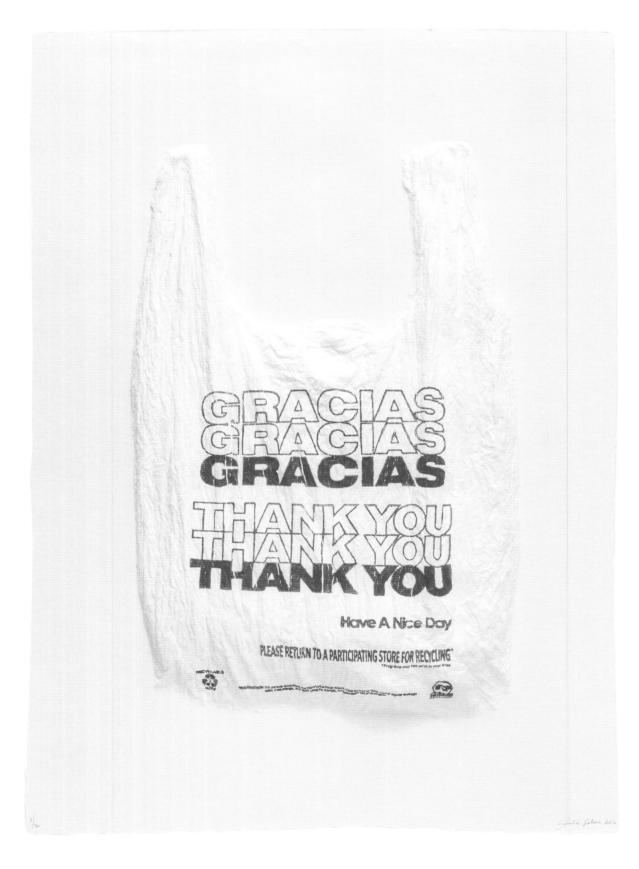

ANALÍA SABAN (Argentinian/argentina, b./n. 1980)
*GRACIAS GRACIAS GRACIAS THANK YOU THANK YOU THANK
YOU Have a Nice Day Plastic Bag/ Bolsa de plástico GRACIAS
GRACIAS GRACIAS THANK YOU THANK YOU THANK YOU
Que tenga un buen día*, edition/edición 7/20, 2016
Mixografia print on handmade paper/Impresión Mixografía en
papel hecho a mano
28½ × 20 × 1½ in. (72.4 × 50.8 × 3.8 cm)

FOREWORD/PRÓLOGO

JILL MCCLEARY

DEPUTY DIRECTOR AND ACTING HEAD/
DIRECTORA ADJUNTA Y JEFA INTERINA

The Art of Food: Highlights from the Collections of Jordan D. Schnitzer and His Family Foundation was originally set to open in fall 2020. However, like many museums across the country, the University of Arizona Museum of Art (UAMA) closed its doors because of the COVID-19 pandemic only a matter of months before the opening date. The pandemic and events of 2020 changed all our lives: as individuals rushed to grocery stores and lines grew at food banks, our perspective on food seemed to change overnight. While food insecurity is already a daily reality for some, the world watched as artists, restaurants, farmers, and essential workers struggled to find their footing in a bewildering new world.

The Art of Food is a testament to the immense role that food plays in art, life, and culture, and it is easy to see why artists repeatedly return to food as a subject of their work. Jordan Schnitzer is a passionate collector and a philanthropist with an impressive, first-class collection of American art. It is thanks to his generosity and vision that this timely exhibition is possible.

Olivia Miller, the exhibition's curator, has chosen works of art that skillfully convey the impact that food has on us all—and reminds us of the unique relationship of food to the University of Arizona and the city of Tucson. From the university's inception over 150 years ago as a land-grant institution, UArizona has been a center for food

Originalmente, la inauguración de *The Art of Food: Highlights from the Collections of Jordan D. Schnitzer and His Family Foundation* estaba programada para el otoño de 2020. Sin embargo, como muchos museos en el país, el Museo de Arte de la Universidad de Arizona (UAMA, por sus siglas en inglés) cerró sus puertas debido a la pandemia de COVID-19 sólo unos meses antes de dicha fecha. La pandemia y otros eventos del 2020 cambiaron todas nuestras vidas: mientras algunas personas se apresuraban a los supermercados y las filas en los bancos de alimentos crecían, nuestra perspectiva sobre la comida parecía cambiar de la noche a la mañana. Si bien la inseguridad alimentaria ya era una realidad cotidiana para algunas personas, el mundo observaba mientras artistas, restaurantes, agricultores y trabajadores esenciales luchaban por encontrar su lugar en un mundo nuevo y desconcertante.

The Art of Food es un testimonio del enorme papel que el alimento juega en el arte, en la vida y en la cultura, y es fácil ver por qué hay artistas que regresan repetidamente a él como tema para su obra. Jordan Schnitzer es un apasionado coleccionista y filántropo con una impresionante colección de arte estadounidense de primera clase. Es gracias a su generosidad y visión que esta oportuna exposición es posible.

Olivia Miller, la curadora de la exposición, ha elegido obras de arte que transmiten con destreza el impacto que la comida tiene sobre los seres humanos, y nos recuerda la relación única de esta con la Universidad de Arizona y con la ciudad de Tucson. Desde su concepción hace más de 150 años como institución

research. Students and professors across campus continue to advance our understanding of food's place in our everyday lives—from nutrition to folklore. Considering Tucson's designation as North America's first UNESCO City of Gastronomy, this is the ideal city, university, and museum to explore the connections between art and food.

It is an honor and a privilege for the University of Arizona Museum of Art to open this groundbreaking exhibition in Tucson and to share it with our communities. Thanks to the incredible generosity of Mr. Schnitzer, this exhibition will bring an active, interdisciplinary lens to the endless ways art and food affect our world, both now and into the future. Special thanks to Catherine Malone, William Morrow, Emily Kramer, Meg Hagyard, Jonathan Mabry, UNESCO City of Gastronomy, Arizona Arts, President Robert C. Robbins, Molly Kalkstein, Brianna Velasco, Violet Rose Arma, UAMA staff, volunteers, and students, and the UAMA Leadership Council.

de concesión de tierras, la Universidad de Arizona ha sido un centro para la investigación del alimento. Estudiantes y profesores en todo el campus continúan avanzando nuestro entendimiento sobre el lugar que guarda la comida en nuestro día a día— desde la nutrición hasta el folklore. Considerando la designación de Tucson como la primera Ciudad de la Gastronomía por la UNESCO en Norteamérica, estos son la ciudad, la universidad y el museo ideales para explorar las conexiones entre el arte y el alimento.

Es un honor y un privilegio para el Museo de Arte de la Universidad de Arizona inaugurar esta innovadora exposición en Tucson y compartirla con nuestras comunidades. Gracias a la increíble generosidad del Sr. Schnitzer, esta exposición dará una lente activa e interdisciplinaria para observar las formas infinitas en que el arte y la comida afectan nuestro mundo, tanto en el presente como en el futuro. Un agradecimiento especial a Catherine Malone, William Morrow, Emily Kramer, Meg Hagyard, Jonathan Mabry, a Ciudad de la Gastronomía de la UNESCO, Artes de Arizona, al Presidente Robert C. Robbins, Molly Kalkstein, Brianna Velasco, Violet Rose Arma, al personal, equipo de voluntaries y estudiantes del UAMA, y al Consejo de Liderazgo del UAMA.

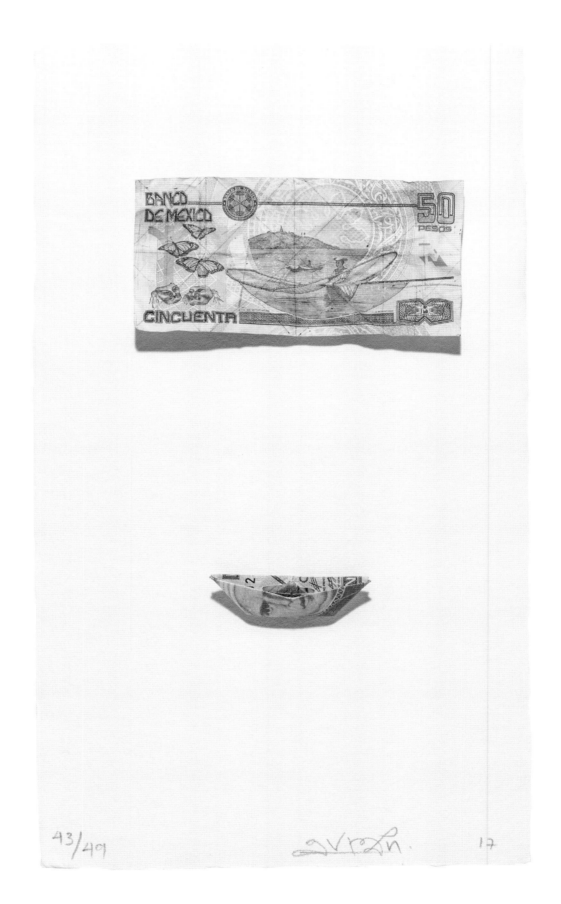

43/49 17

ABRAHAM CRUZVILLEGAS (Mexican/mexicano, b./n. 1968)
Ichárhuta, edition/edición 43/49, 2017
Mixografia print on handmade paper and archival pigment print/
Impresión Mixografía sobre papel hecho a mano e impresión de
archivo pigmentada
12¾ × 7½ in. (32.4 × 19.1 cm)

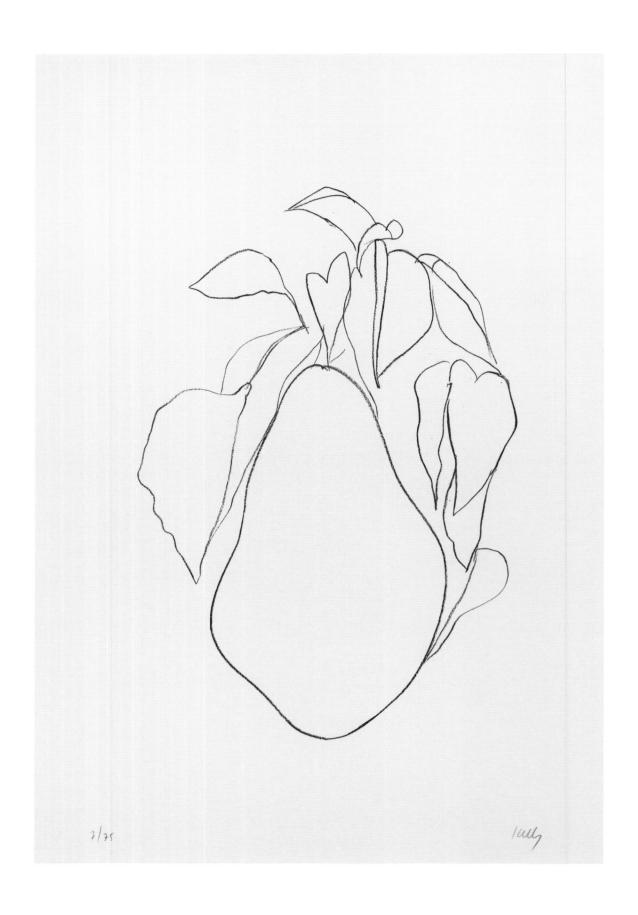

7/75 Kelly

ELLSWORTH KELLY (American/estadounidense, 1923–2015)
Suite of Plant Lithographs: Pear I (Poire I)/Conjunto de litografías de plantas: Pera I (Poire I), edition/edición 7/75, 1965–66
Lithograph/Litografía
35⅝ × 24½ in. (90.5 × 62.2 cm)

COLLECTOR'S STATEMENT/
DECLARACIÓN DEL COLECCIONISTA

JORDAN D. SCHNITZER

When I was in the third grade, my mother opened the Fountain Gallery of Art in Portland, Oregon, where I grew up and still reside today. A cultural hub in Portland for over twenty-five years, her gallery exhibited the most influential Pacific Northwest contemporary artists. Being around art inspired my love of collecting early on, and I purchased my first work of art at age fourteen. In the late 1980s, in addition to continuing to buy art of the contemporary Northwest artists I grew up with, I began to collect prints and multiples by renowned American modern masters and major contemporary artists. My collection now exceeds 19,000 works, and our national exhibition program, drawn entirely from our collection, has traveled to more than 150 museums in this country and abroad.

When Olivia Miller, curator of exhibitions at the University of Arizona Museum of Art, first approached me about doing an exhibition from my collection with food as the subject, I was intrigued. The rich culinary heritage of Tucson, where the University of Arizona's museum and campus are located, has earned it the distinction of being a UNESCO City of Gastronomy. Therefore, I could not think of a better place to begin this exhibition's tour, offering visitors the chance to see artworks that make us consider the nature of food in society. What we eat, where it is grown, and who grows it are central issues for all of us today.

Cuando estaba en el tercer grado, mi madre abrió la galería de arte *Fountain Gallery of Art* en Portland, Oregon, donde crecí y donde he vivido hasta el día de hoy. Un centro cultural en Portland por más de veinticinco años, su galería exhibió el trabajo de les artistas contemporánees más influyentes del Pacífico Noroeste. Estar rodeado de arte inspiró mi amor por coleccionarlo desde temprana edad, y compré mi primera obra a los catorce años. A finales de los ochentas, además de continuar comprando el arte de les artistas contemporánees del Noroeste con quienes crecí, también empecé a coleccionar grabados y múltiples de les reconocides maestres modernes estadounidenses y de les grandes artistas contemporánees. Mi colección ahora cuenta con más de 19,000 obras, y nuestro programa nacional de exposiciones, compuesto completamente por obras de nuestra colección, ha viajado a más de 150 museos en este país y en el extranjero.

Cuando Olivia Miller, curadora de exposiciones en el Museo de Arte de la Universidad de Arizona, me propuso hacer una exposición con piezas de mi colección que abordan el tema de la comida, quedé intrigado. La rica herencia culinaria de Tucson, donde se encuentran el museo y el campus de la Universidad de Arizona, le ha valido la distinción de ser una Ciudad de la Gastronomía de la UNESCO. Por lo tanto, no se me pudo haber ocurrido un lugar más apropiado para comenzar el recorrido de esta exposición, ofreciendo a les visitantes la oportunidad de ver obras de arte que nos hacen reflexionar sobre el carácter de la comida en la sociedad. Qué

This exhibition showcases some of the most important artists of the recent past, like John Baldessari, Ellsworth Kelly, Roy Lichtenstein, Robert Rauschenberg, and Andy Warhol. It also highlights work from some of the leading artistic voices of today, including David Hockney, Hung Liu, Ed Ruscha, Alison Saar, and Lorna Simpson. With 109 works by 37 artists, the variety in this exhibition is truly remarkable.

In addition to thanking Olivia and the staff at the University of Arizona Museum of Art, I am always appreciative of the work of Catherine Malone, our director of collections; William Morrow, our director of exhibitions; and the eleven hardworking staff at JSFF—without whom the art would not make its way from our warehouse to world-class museums!

As a collector, I know how art can inform, confound, elicit joy, and ultimately enrich our lives. For me, waking up each day without art would be like waking up without the sun! Therefore, I would like to thank all the artists featured in this exhibition for creating art that makes me see the world in new ways. For that, all of us who view your art are grateful. I hope each visitor is as enchanted as I am by this exhibition and finds many themes that speak to them.

comemos, dónde se cultiva y quién lo cultiva son temas centrales para todas las personas hoy en día.

Esta exposición exhibe a algunes de les artistas más importantes del pasado reciente, como John Baldessari, Ellsworth Kelly, Roy Lichtenstein, Robert Rauschenberg y Andy Warhol. También destaca la obra de algunas de las principales voces artísticas de la actualidad, incluidas las de David Hockney, Hung Liu, Ed Ruscha, Alison Saar y Lorna Simpson. Con 109 obras de 37 artistas, la variedad de esta exposición es verdaderamente excepcional.

Además de agradecer a Olivia y al personal del Museo de Arte de la Universidad de Arizona, siempre aprecio el trabajo de Catherine Malone, nuestra directora de colecciones; de William Morrow, nuestro director de exposiciones; y de les once dedicados trabajadores de la JSFF—¡sin les cuales el arte no saldría de nuestro almacén para llegar hasta los museos de primera categoría!

Como coleccionista, sé que el arte puede informar, confundir, suscitar alegría y, en última instancia, enriquecer nuestras vidas. ¡Para mí, despertarme cada día sin arte sería como despertar sin el sol! Por lo tanto, me gustaría agradecer a todes les artistas presentades en esta exposición por crear arte que me hace ver el mundo de nuevas formas. Por esto, todas las personas que miramos su arte estamos agradecidas. Espero que cada visitante esté tan encantade con esta exposición como yo y que encuentre muchos temas que le hagan eco.

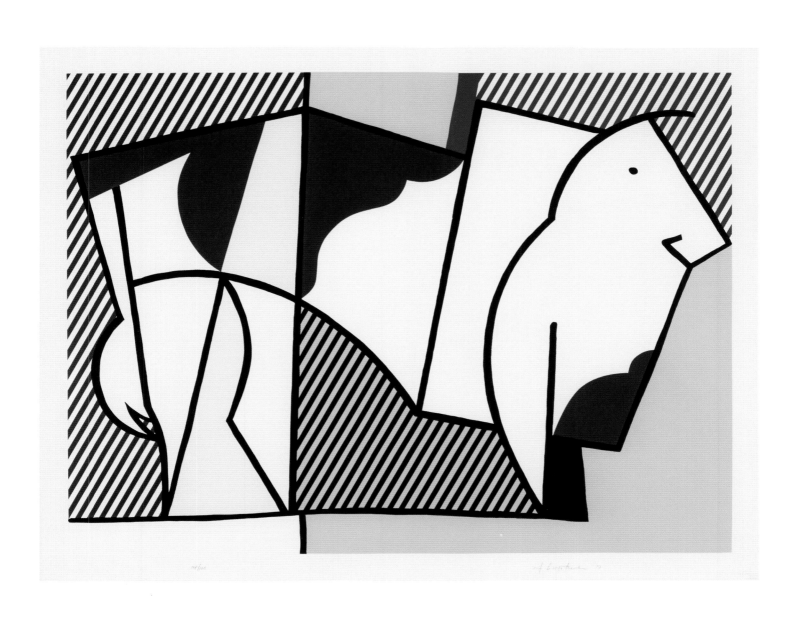

ROY LICHTENSTEIN (American/estadounidense, 1923–1997)
Bull Profile Series, Bull III/Serie de perfiles de toro, Toro III,
edition/edición 14/100, 1973
Screenprint, lithograph, linocut/Serigrafía, litografía, linograbado
27 × 35¹⁄₁₆ in. (68.6 × 89.1 cm)

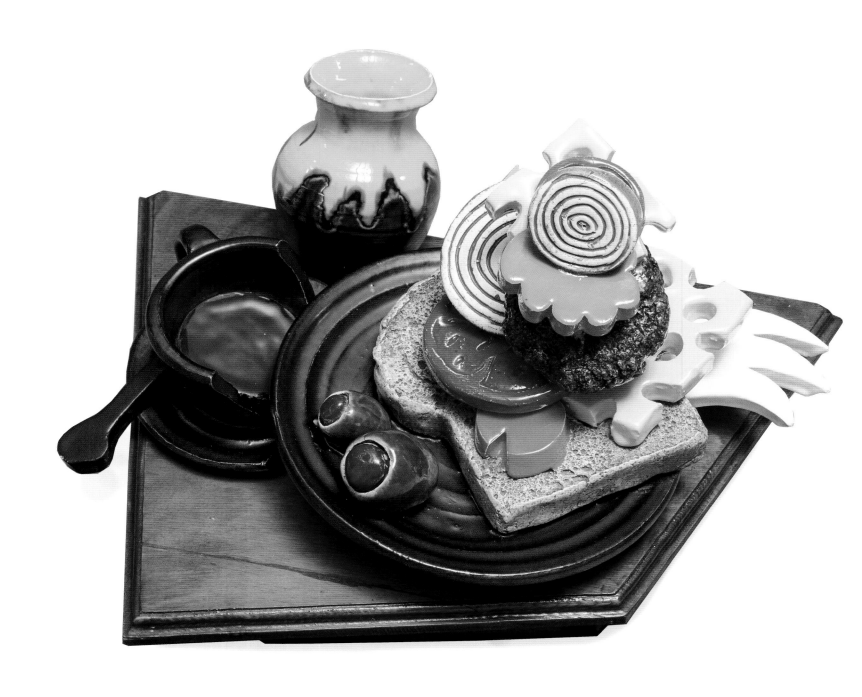

DAVID GILHOOLY (American/estadounidense, 1943–2013)
Lite/Late Lunch/Almuerzo ligero/tardío, 1983
Painted and glazed ceramic and wood/Cerámica pintada y
esmaltada y madera
13 × 20 × 15½ in. (33 × 50.8 × 39.4 cm)

INTRODUCTION: WHY TUCSON?/ INTRODUCCIÓN: ¿POR QUÉ TUCSON?

JONATHAN MABRY

EXECUTIVE DIRECTOR, TUCSON CITY OF GASTRONOMY/
DIRECTOR EJECUTIVO, CIUDAD DE LA GASTRONOMÍA DE TUCSON

Tucson is one of America's oldest communities, with a history of continuous cultivation and habitation extending back more than four thousand years. It was the first city in the United States designated by the United Nations Educational, Scientific, and Cultural Organization (UNESCO) as a Creative City of Gastronomy. UNESCO's definition of "gastronomy" focuses on food traditions as living cultural heritage. The designation not only recognizes the global significance of Tucson's deep food history, multicultural cuisine, and innovative food system but also the "universal value" of our living food heritage to all the peoples of the world.

The designation, then, makes Tucson an ideal place to launch the exhibition *The Art of Food: Highlights from the Collections of Jordan D. Schnitzer and His Family Foundation,* which explores the cultural meanings of food through the eyes of artists of the twentieth and twenty-first centuries. It leads us to think about how food and art are both cultural products, and about the similarities between foodies and art lovers. In her book *Eating Culture*, the anthropologist Gillian Crowther observes: "Food is our everyday creative and meaningful engagement with nature through culture; indeed, food becomes cultured nature, an artifact. . . . This is an intimate relationship with an artifact, like no other; food is the only consumed cultural artifact

Tucson es una de las comunidades más antiguas de Estados Unidos, con una historia continua de cultivo y habitación que se remonta a más de cuatro mil años. Fue la primera ciudad en Estados Unidos designada como Ciudad Creativa de la Gastronomía por la Organización de las Naciones Unidas para la Educación, la Ciencia y la Cultura (UNESCO). La definición de "gastronomía" de la UNESCO está basada en las tradiciones alimentarias como herencia cultural viva. La designación no solo reconoce la importancia global de la extensa historia alimentaria, la cocina multicultural y el innovador sistema alimentario de Tucson, sino también el "valor universal" de nuestra herencia alimentaria viva para todos los pueblos del mundo.

La designación, entonces, convierte a Tucson en un lugar ideal para inaugurar la exposición *The Art of Food: Highlights from the Collections of Jordan D. Schnitzer and His Family Foundation*, que explora los significados culturales de la comida a través de los ojos de diferentes artistas de los siglos XX y XXI. La exposición nos invita a pensar en cómo la comida y el arte son productos culturales, y en las similitudes entre amantes de la comida y amantes del arte. En su libro *Eating Culture*, la antropóloga Gillian Crowther escribe: "La comida es nuestro compromiso creativo y significativo diario con la naturaleza mediante la cultura; en efecto, la comida se convierte en naturaleza cultivada, en un artefacto.(...) Esta es una relación íntima con un artefacto, como ninguna otra; la comida es el único artefacto cultural que consumimos que literalmente se convierte en nosotros."

that quite literally becomes us." These works of art add still more layers of culture to the ultimate artifact.

Gastronomy has always been a loaded term, but its shifting essence in the wake of globalization is informative for understanding the changing ways we consume and interpret cultural products in general, including art. The sociologists Josée Johnston and Shyon Baumann have argued that with globalization, gastronomy has evolved and should no longer be understood as a fixed set of culinary practices and strategies for displaying status, but rather as a fluid and omnivorous mode of cultural consumption involving public discourse, where legitimacy is framed by concepts of authenticity and exoticism. Through these two frames, omnivorous cultural consumption—in which cultural forms outside the dominant Western canon can be appreciated equally—allows gastronomes (or "foodies") to negotiate a fundamental ideological tension between inclusivity and exclusivity, democracy and distinction. The diversity of this exhibition shows how consumption of art has similarly become a more inclusive and omnivorous cultural realm.

Surprisingly, the authenticities of cultural products are not fixed but evolving. The focus on "creativity" in the UNESCO Creative Cities program is important in that it combats a long-standing critique of UNESCO's embrace of Western ideals of "authentic" heritage as situated in an unchanging past. UNESCO is aware of

Estas obras de arte añaden aún más capas de cultura al artefacto definitivo.

"Gastronomía" siempre ha sido un término cargado de connotaciones, pero su esencia versátil tras la globalización nos ayuda a entender las formas cambiantes en que consumimos e interpretamos los productos culturales en general, incluyendo al arte. La socióloga Josée Johnston y el sociólogo Shyon Baumann han argumentado que con la globalización, la gastronomía ha evolucionado y ya no debe entenderse como un conjunto fijo de prácticas y de estrategias culinarias para mostrar estatus, sino como un modo de consumo cultural fluido y omnívoro que involucra al discurso público, donde la legitimidad está enmarcada por los conceptos de autenticidad y exotismo. Con estos dos marcos, el consumo cultural omnívoro—en el que se pueden apreciar igualmente las formas culturales que están fuera del canon occidental dominante—permite a les gastrónomes (o "amantes de la comida") negociar una tensión ideológica fundamental entre inclusión y exclusividad, democracia y distinción. La diversidad de esta exposición muestra cómo el consumo de arte se ha convertido de manera similar en un ámbito cultural más inclusivo y omnívoro.

Sorprendentemente, las autenticidades de los productos culturales no están fijas sino en evolución. El enfoque en la "creatividad" del programa de Ciudades Creativas de la UNESCO es importante porque combate una prolongada crítica sobre la adopción por parte de la UNESCO de los ideales occidentales de la herencia cultural "auténtica" como una situada en un pasado inmutable. La UNESCO está consciente de los riesgos de codificar permanentemente una tradición viva al agregarla a una lista

the potential dangers of permanently codifying a living tradition by adding it to an officially curated list, as they acknowledge this could lead to "freezing heritage through a folklorisation process." For UNESCO, the concept of safeguarding a culinary tradition through formal recognition is not about enshrining a fixed notion of authenticity but about ensuring it will be culturally transmitted between generations because it remains relevant and meaningful to the community itself; it is "continuously recreated." New dishes created by Tucson's chefs with heritage ingredients are just as authentic expressions of the region's cuisine as are faithful replications of traditional dishes.

Like authenticity, exoticism is a valued quality for cultural omnivores of both food and art. Increasingly, the motivation to consume the exotic Other is to escape cultural parochialism and experience meaningful cultural exchanges. This eclectic art exhibition about food, while including unexpected and norm-breaking works, is inclusive in that way and invites tolerance, curiosity, and a broadening of appreciation. It is also representative of the cultural omnivore's paradox: while we prefer the familiar in food and art, we are attracted to the new and different. Interacting with this exhibition is choosing to consume cultural products that give us insights into diversely creative but equally authentic expressions of meanings of food that stay relevant—a fitting experience in a Creative City of Gastronomy.

curada oficialmente, ya que reconoce que esto podría resultar en "congelar la herencia cultural a través de un proceso de folclorización". Para la UNESCO, la idea de salvaguardar una tradición culinaria a través del reconocimiento formal no intenta consagrar una noción fija de autenticidad, sino de asegurar que se transmitirá culturalmente de generación en generación porque sigue siendo relevante y significativa para la comunidad misma; la tradición culinaria se "recrea continuamente". Los platillos nuevos creados por les chefs de Tucson con ingredientes tradicionales son expresiones tan auténticas de la cocina de la región como lo son las fieles réplicas de platillos típicos.

Como la autenticidad, el exotismo es una cualidad que les consumidores culturales omnívoros valoran tanto de los alimentos como del arte. Cada vez más, la motivación de consumir al "otre exótique" es la de escapar de un entendimiento cultural estrecho para experimentar intercambios culturales significativos. Esta ecléctica exposición de arte sobre comida, si bien incluye obras inesperadas que rompen con las normas, también es inclusiva de esa manera e invita a la tolerancia, a la curiosidad y a una apreciación más amplia. Es representativa también de la paradoja del omnívore cultural: aunque preferimos lo familiar en la comida y en el arte, nos atrae lo nuevo y lo diferente. Interactuar con esta exposición es elegir consumir los productos culturales que nos ofrecen un entendimiento perspicaz sobre expresiones de significados diversamente creativos, pero igualmente auténticos, que se mantienen relevantes—una experiencia adecuada en una Ciudad Creativa de la Gastronomía.

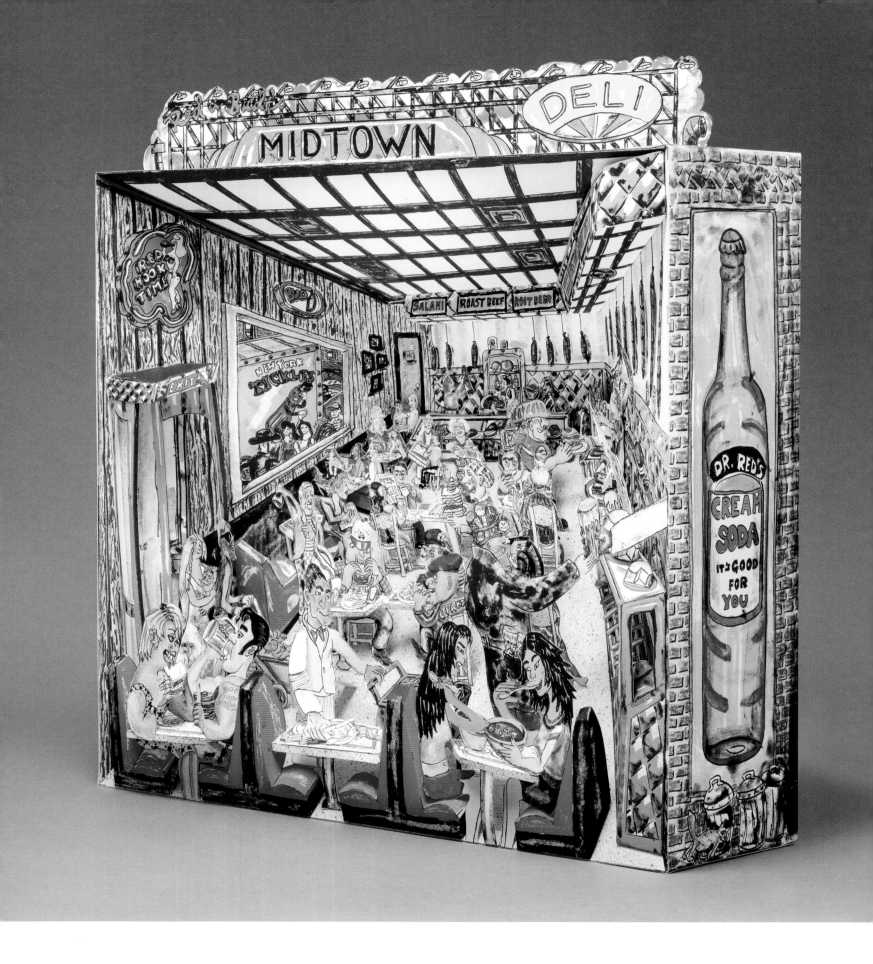

RED GROOMS (American/estadounidense, b./n. 1937)
Deli/Lonchería, edition/edición 38/50, 2004
Three-dimensional lithograph/Litografía tridimensional
26½ × 26⅜ × 7⅝ in. (67.3 × 67 × 19.4 cm)

THE ART OF FOOD/
EL ARTE DE LA COMIDA

OLIVIA MILLER

CURATOR OF EXHIBITIONS/CURADORA DE EXPOSICIONES

The truth is that at the end of a well-savored meal both soul and body enjoy an especial well-being.

Jean Anthelme Brillat-Savarin, *The Physiology of Taste*, 1825

In its most prosaic sense, food is a physical necessity for survival, yet its overall significance transcends mere sustenance. Food is integral to our communities, relationships, cultures, and languages. People interact with food on varying levels. Some of us grow it; more of us buy it. We transform it by cutting, cooking, and dressing it with spices, marinades, and garnishes. We use food as an intermediary to connect with others through holiday meals, business lunches, dates, and more. We fight over food. We deny food to others as a tool of suppression and cultural erasure. We are fearful about our health, about feeding a growing global population, and about the effects of climate change on food production. It is no wonder then that artists continue to reflect on food, ever since the spark of human creativity was ignited thousands of years ago.

The Art of Food: Highlights from the Collections of Jordan D. Schnitzer and His Family Foundation examines how visual artists in the twentieth and twenty-first centuries have considered the universal subject of food. Organized thematically, the exhibition shows how art provides a lens with which to examine food beyond its purpose as body fuel.

Lo cierto es que al final de una comida bien degustada, tanto el alma como el cuerpo disfrutan de un bienestar especial.

Jean Anthelme Brillat-Savarin, *Fisiología del gusto*, 1825

En su sentido más prosaico, la alimentación es una necesidad física para la supervivencia, pero su importancia general trasciende el mero sustento. El alimento es parte integral de nuestras comunidades, relaciones, culturas e idiomas. Las personas interactúan con el alimento en distintos niveles. Algunes de nosotres lo cultivamos; más de nosotres lo compramos. Lo transformamos cortándolo, cocinándolo y aderezándolo con especias, adobos y guarniciones. Utilizamos al alimento como intermediario para conectar con otros individuos a través de comidas festivas, almuerzos de negocios, citas y más. Nos peleamos por el alimento. Se lo negamos a otras personas como una herramienta de represión y exterminación cultural. Tememos por nuestra salud, por alimentar a una población mundial en crecimiento y por los efectos del cambio climático en la producción de alimentos. No es de extrañar, entonces, que les artistas sigan reflexionando sobre la comida desde que se encendió la chispa de la creatividad humana hace miles de años.

The Art of Food: Highlights from the Collections of Jordan D. Schnitzer and His Family Foundation examina cómo diferentes artistas visuales de los siglos XX y XXI han investigado el tema universal del alimento. Organizada por temas, la exposición muestra cómo el arte nos proporciona una lente con la cual examinar los alimentos más allá de su propósito como combustible corporal.

COMMUNITY

In his seminal book *The Physiology of Taste* (1825), Jean Anthelme Brillat-Savarin states: "The pleasure of eating is the actual and direct sensation of satisfying a need. The pleasures of the table are a reflective sensation which is born from the various circumstances of place, time, things, and people who make up the surroundings of the meal."[1] This human relationship with food that feeds both body and mind creates a sense of community and occasion that moves beyond the physical and into the realm of spiritual fulfillment. Community can be felt on many levels—in the most sacred of ceremonies among many participants or at a casual lunch with a friend. As the year 2020 demonstrated for so many, feelings of isolation are exacerbated by limitations around dining.

Over the course of his artistic career, Red Grooms has worked with a variety of subjects, but he clearly revels in the dynamism and variety of New York City. With endless sites to choose from, Grooms is especially drawn to scenes of everyday life. *Deli* (2004) is a colorful three-dimensional lithograph that offers a glimpse into a prototypical New York deli. This packed restaurant features friends, couples, families, and coworkers who have stopped in for a quick lunch. Grooms depicts a hurried moment in time—some figures are even mid-bite—and the din of conversation and clattering of dishes is palpable. This work has taken on new significance in light of the COVID-19 pandemic, as many remember the past ease of dining in a crowded indoor space.

Even when a work of art does not directly depict people, community and celebration may be implicit by the type of food represented. For example, a roast turkey on a platter evokes the

COMUNIDAD

En su influyente libro, *Fisiología del gusto* (1825), Jean Anthelme Brillat-Savarin declara que: "El placer de comer es la sensación real y directa de satisfacer una necesidad. Los placeres de la mesa son una sensación reflejante que nace de las diversas circunstancias de lugar, tiempo, cosas y personas que conforman el ambiente de las comidas".[1] Esta relación humana con la comida que alimenta tanto al cuerpo como a la mente crea un sentido de comunidad y de acontecimiento especial que va más allá de lo fisiológico y que se adentra en el ámbito de la realización espiritual. El sentido de comunidad puede apreciarse en diferentes grados—ya sea en la ceremonia más sagrada con numerosos participantes o en un almuerzo informal con una amistad. Como el año 2020 lo demostró para tantas personas, los sentimientos de aislamiento son exacerbados por las limitaciones en torno a las comidas.

A lo largo de su carrera artística, Red Grooms ha trabajado con una gran variedad de temas, pero claramente se deleita con el dinamismo y la variedad de la ciudad de Nueva York. Con un sinfín de sitios de donde escoger, Grooms está particularmente interesado en las escenas de la vida cotidiana. *Lonchería* (2004) es una colorida litografía tridimensional que ofrece un vistazo a un *deli* prototípico de Nueva York. Este restaurante repleto de gente cuenta con amistades, familias y colegas que han entrado para un almuerzo rápido. Grooms nos muestra un momento apresurado—algunos personajes incluso están a medio bocado—y el barullo de la conversación y el ruido estrepitoso de los platos es palpable. Esta pieza ha adquirido un nuevo significado a partir de la pandemia de COVID-19, ya que muchas personas recuerdan con nostalgia la posibilidad y facilidad de comer en un espacio cerrado y concurrido.

Incluso cuando una obra de arte no muestra a personas directamente, la comunidad y la celebración pueden estar implícitas en el tipo de alimento representado. Por ejemplo, un pavo asado en una bandeja evoca las tradiciones de la cena de Acción de Gracias;

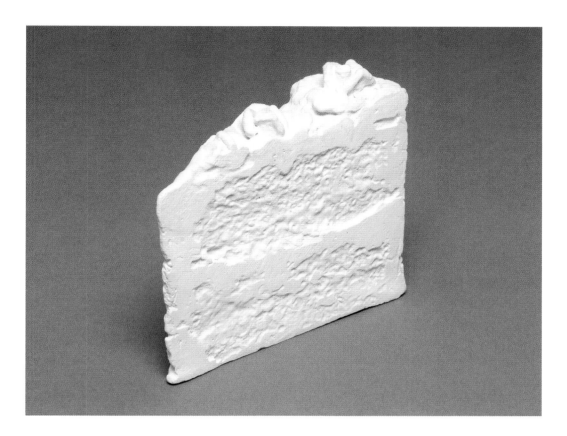

CLAES OLDENBURG (American, b. Sweden/estadounidense, n. Suecia, 1929)
Wedding Souvenir/Recuerdo de boda, exhibition proof of an edition of approx. 200/prueba para exposición de una edición de 200 aprox., 1966
Plaster and white paint/Yeso y pintura blanca
5½ × 6½ × 2¼ in. (14 × 16.5 × 5.7 cm)

traditions of a Thanksgiving meal; a cake with candles signals a birthday celebration.[2] Created as favors for the nuptials of James Elliott, the former contemporary art curator at the Los Angeles County Museum of Art, and Judith Algar, Claes Oldenburg's *Wedding Souvenir* (1966) is a plaster sculpture of a slice of double-layered white cake, decorated with roses and thick frosting.[3] At the cutting of the cake, a popular ritual at wedding receptions, guests delight in watching the spouses cut and feed each other cake before sharing in the treat themselves as a hopeful communion for the couple's future. True to Oldenburg's humorous style, the hard texture of the sculpture belies its subject as a soft, sugary confection. Oldenburg, as well as Elliott and Algar, who chose not to serve actual cake at their reception, subverts the wedding tradition by serving an inedible treat to the guests.

un pastel con velitas indica un festejo de cumpleaños.[2] Creado como un obsequio por las nupcias de James Elliott, ex curador de arte contemporáneo en el Museo de Arte del Condado de Los Ángeles, y de Judith Algar, *Recuerdo de boda* (1966) de Claes Oldenburg es una escultura hecha de yeso de una rebanada doble de pastel blanco, decorada con rosas y con un espeso betún.[3] Al partir el pastel, un ritual popular en las recepciones de bodas, les invitades se deleitan viendo a les cónyuges partir una rebanada y ofrecerse un bocado antes de compartir el postre como una comunión esperanzadora para el futuro de la pareja. Propio del estilo humorístico de Oldenburg, la textura dura de la escultura se desmiente como una confección suave y dulce. Oldenburg, como Elliott y Algar, quienes optaron por no servir un pastel real en su recepción, subvierte la tradición de bodas al ofrecer un manjar incomestible a les invitades.

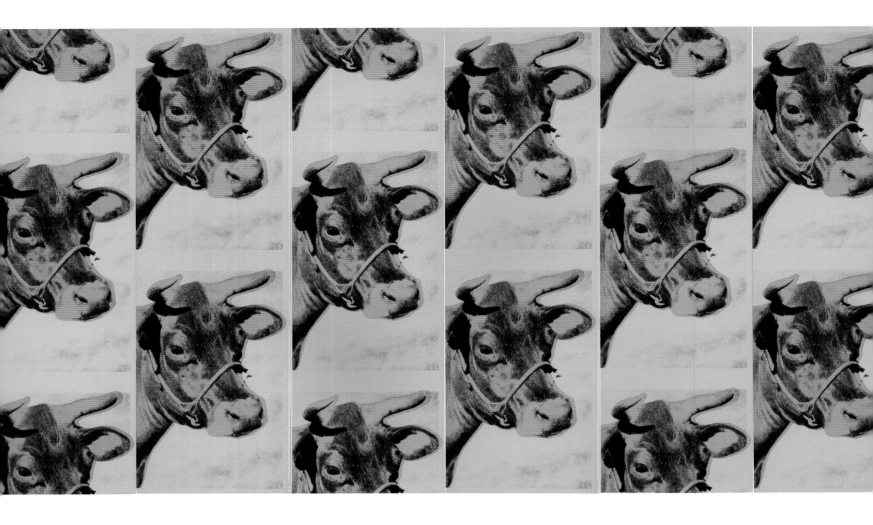

DISSOCIATION

Preoccupied with American consumerism, pop artists of the mid-twentieth century were especially eager to explore food's commercialism. When the art dealer Ivan Karp suggested to Andy Warhol that he "paint some cows," Warhol took the suggestion literally and created a series of screenprints and wallpaper depicting Barclay's Betty, a dairy cow that Warhol found in an animal husbandry book.[4] In *Cow* (1966), the repetition of Barclay's Betty's head conjures up factory farms and people's ability to separate their consumption of a meat product from the individual animal. The ease of purchasing meat from a grocery store, where it has already been butchered and neatly packaged, furthers our dissociation from its source.

Richard Estes's *Supermarket, San Francisco* (1979) is a testimony to this convenience of urban

DISOCIACIÓN

Preocupados por el consumismo estadounidense, les artistas pop de mediados del siglo XX estuvieron especialmente entusiasmados por explorar el comercialismo en la comida. Cuando el comerciante de arte Ivan Karp le sugirió a Andy Warhol que "pintara unas vacas", Warhol siguió la sugerencia literalmente y creó una serie de serigrafías y de papel tapiz con Barclay's Betty, una vaca lechera que Warhol encontró en un libro sobre cría de animales.[4] En *Vaca* (1966), la repetición de la cabeza de Barclay's Betty invoca granjas industriales y la capacidad humana de separar su consumo de productos cárnicos de un animal concreto. La facilidad de comprar carne en un supermercado donde esta ya ha sido descuartizada y empaquetada cuidadosamente fomenta nuestra disociación de su origen.

Supermercado, San Francisco (1979) de Richard Estes es un testimonio de esta conveniencia de la vida urbana. Lejos de las granjas y de los campos, las

RICHARD ESTES (American/estadounidense, b./n. 1936)
*Urban Landscapes II: Supermarket, San Francisco/Paisajes urbanos
II: Supermercado, San Francisco*, edition/edición 57/100, 1979
Screenprint/Serigrafía
27½ × 19½ in. (69.9 × 49.5 cm)

(opposite page/página opuesta) ANDY WARHOL (American/
estadounidense, 1928–1987)
Cow 1966/Vaca 1966, 1966
Screenprint on wallpaper mounted to canvas/Serigrafía sobre papel
pintado montado en lienzo
90 × 174 in. (228.6 × 442 cm)

living. Far removed from farms and fields, this supermarket's sleek glass windows reflect the surrounding urban environment. Jonathan Seliger's *Fresh* (2001) is a realistic imitation of a Table Talk pie, just like one that might be found in such a supermarket. This work is an ironic reflection on the American diet that asks us to contemplate the definition of fresh food, especially in regard to ready-made and packaged foods. The orange sticker haphazardly slapped onto the plastic film is a nod to American consumerism and the lure of a bargain—one can enjoy this "fresh" pie for the low price of fifty cents.

Another instance of dissociation is Analía Saban's sculptural print *Thank You For Your Business*

ventanas de vidrio impecables de este supermercado reflejan el entorno urbano. *Fresco* (2001) de Jonathan Seliger es una imitación realista de una tarta marca Table Talk, precisamente como la que se podría encontrar en dicho supermercado. Esta pieza es una irónica reflexión sobre la dieta estadounidense que nos hace repensar la definición de comida fresca, especialmente con relación a los alimentos preparados y empacados. La estampa naranja, pegada al azar sobre la película de plástico, es un guiño al consumismo estadounidense y a lo atractivo de una rebaja—se puede disfrutar esta tarta "fresca" por el precio mínimo de cincuenta centavos.

Otro caso de disociación es el grabado escultórico *Bolsa de plástico Gracias por su compra* (2016) de Analía Saban, el cual replica meticulosamente la

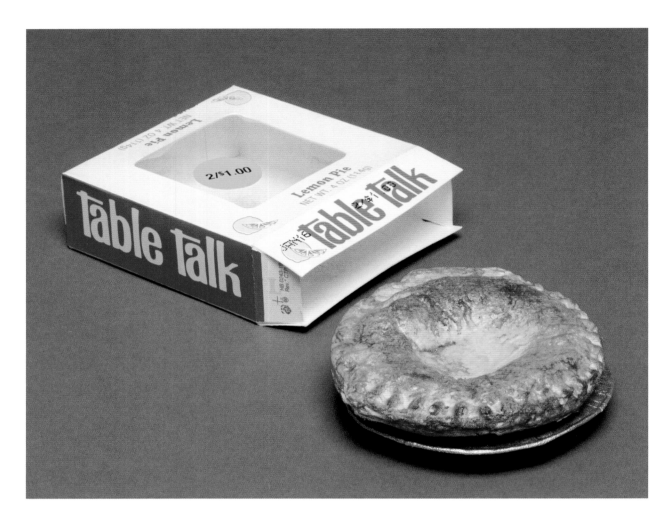

JONATHAN SELIGER (American/estadounidense, b./n. 1955)
Fresh/Fresco, edition/edición 52/75, 2001
Cotton, pigment, aluminum powder, silkscreen, Mylar/Algodón,
pigmento, polvo de aluminio, serigrafía, Mylar
1½ × 4¼ × 4¼ in. (3.8 × 10.8 × 10.8 cm)

Plastic Bag (2016), which meticulously mimics the generic and ubiquitous disposable plastic bag. A conceptual piece in that it questions what subjects are worthy of being the focus of art, it also calls to mind the excessive waste produced by consumerism and the misguided perception that the earth's resources are endless.

CONTROL

Despite the relative prevalence of supermarkets and outdoor farmers' markets, not everyone has equal access to food. Some people spend their lives dependent on a food system already in place, while others work to regain

genérica y ubicua bolsa de plástico desechable. Una pieza conceptual que cuestiona qué temas son dignos de ser objeto del arte, también nos recuerda el derroche excesivo que producen el consumismo y la percepción equivocada de que los recursos de la tierra son infinitos.

CONTROL

A pesar de la relativa predominancia de los supermercados y de los mercados de agricultores al aire libre, no todas las personas tienen el mismo acceso al alimento. Algunas pasan sus vidas dependiendo de un sistema alimentario preexistente, mientras que otras luchan por recuperar la soberanía alimentaria de su comunidad.[5] Privar a una comunidad de sus

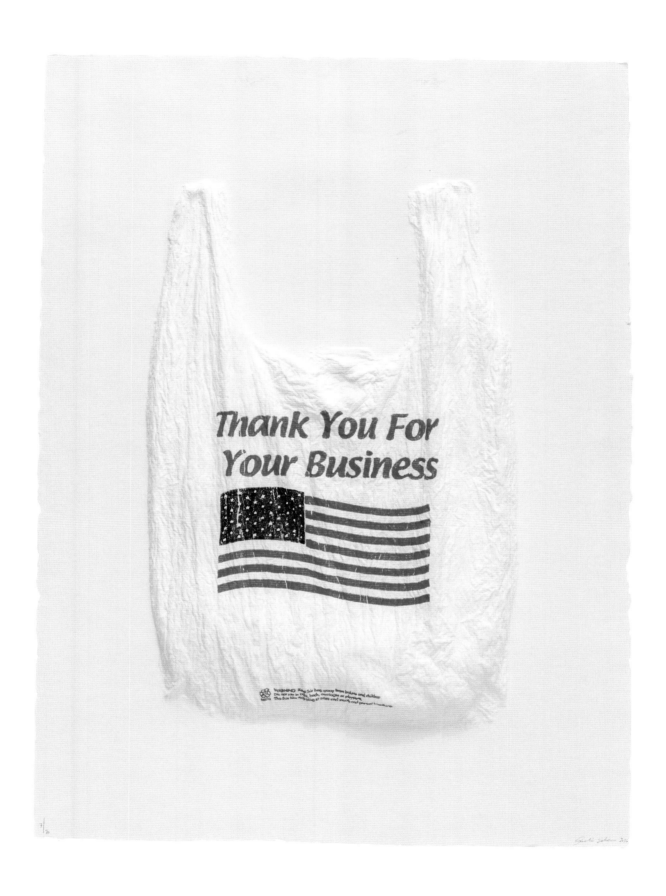

ANALÍA SABAN (Argentinian/argentina, b./n. 1980)
*Thank You For Your Business Plastic Bag/Bolsa de plástico Gracias
por su compra,* edition/edición 7/20, 2016
Mixografia print on handmade paper/Impresión Mixografía en
papel hecho a mano
28½ × 20 × 1½ in. (72.4 × 50.8 × 3.8 cm)

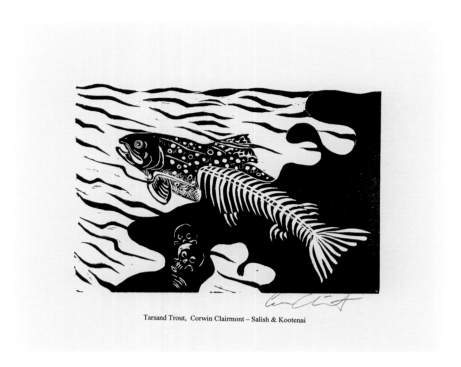

Tarsand Trout, Corwin Clairmont – Salish & Kootenai

CORWIN "CORKY" CLAIRMONT (Native American,
Salish-Kootenai/nativo norteamericano, Salish-Kootenai,
b./n. 1946)
Tarsand Trout/Trucha de Tar Sands, edition/edición 29/92, 2014
Relief print/Grabado en relieve
8 × 10 in. (20.3 × 25.4 cm)

their community's food sovereignty.[5] Denying a community its traditional food systems is an especially effective way to subjugate and negate a culture. Control over land and food access is just one of the systemic ways that colonialism has repercussions on various communities.

The multimedia artist Corwin "Corky" Clairmont (Salish-Kootenai) centers such destruction of the traditional foodways of many First Nations communities in his print *Tarsand Trout* (2014), which illustrates the effects of the Suncor mining operations at the Athabasca Tar Sands in Alberta, Canada. Clairmont's print depicts a swimming trout: the front half of its body resembles a living fish in the water, but the back half has become a skeleton, taken over by black tar. The skulls below highlight the toxicity of the water, a deadly result of pollution from the nearby mining operation. A cherished coexistence with the river since time immemorial is now contaminated, a consequence of monetary priorities over land and people.

sistemas alimentarios tradicionales es una manera especialmente eficaz de subyugar y de negar a una cultura. Una de las maneras sistémicas en las que han persistido las repercusiones del colonialismo es a través del control sobre el acceso a la tierra y al alimento.

El artista multimedia Corwin "Corky" Clairmont (Salish-Kootenai) se enfoca en dicha destrucción de las prácticas alimentarias tradicionales de muchas comunidades de las Primeras Naciones en su grabado *Trucha de Tar Sands* (2014), que ilustra los efectos de la industria minera de Suncor en Athabasca Tar Sands en Alberta, Canadá (Arenas Alquitranadas de Athabasca). El grabado de Clairmont muestra una trucha nadando: la mitad delantera de su cuerpo se asemeja a la de un pez vivo en el agua, pero la mitad trasera se ha convertido en un esqueleto cubierto de alquitrán negro. Los cráneos debajo destacan la toxicidad del agua, resultado mortal de la contaminación de la industria minera cercana. Una atesorada coexistencia con el río desde tiempos inmemoriales que ahora está contaminada como consecuencia de las prioridades monetarias por encima del territorio y de los seres humanos.

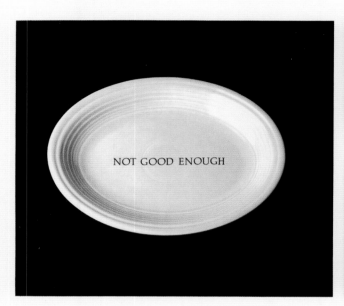
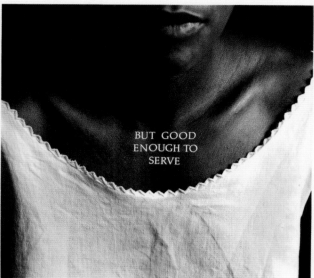

NOT GOOD ENOUGH

BUT GOOD ENOUGH TO SERVE

LORNA SIMPSON (American/estadounidense, b./n. 1960)
C-Ration/Ración C, edition/edición AP 1/10, 1991
2 silver gelatin prints/Impresión en plata sobre gelatina
Overall: 24¾ × 48³⁄₁₆ in (62.9 × 122.4 cm)
Each image: 18¹³⁄₁₆ × 42¼ in. (47.8 × 107.3 cm)

Lorna Simpson's black-and-white diptych *C-Ration* (1991) also focuses on the concept of food control. The left photograph depicts a white plate with the words "not good enough"; the right photograph depicts a Black woman with the words "but good enough to serve" superimposed on her chest. The woman's cropped face makes her unidentifiable, underscoring the cruel degradation she and so many other enslaved Black women endured. While she is expected to make and serve food, she is not good enough to consume the same type of meal herself, suggesting that her only worth is her labor in a southern white woman's kitchen. Far from being a relic of the past, as food archaeologist Kelley Fanto Deetz explains: "The lingering ideological memory of enslaved cooks is entrenched in American grocery and culinary trends. Boxes of Aunt Jemima pancake mix and Uncle Ben's rice fill our grocers' shelves, using the images of enslaved cooks to authenticate these products."[6]

El díptico en blanco y negro de Lorna Simpson, *Ración C* (1991), también aborda el concepto de control alimentario. La fotografía de la izquierda muestra un plato blanco con las palabras "no lo suficientemente buena"; la fotografía de la derecha muestra a una mujer Negra con las palabras "pero suficientemente buena para servir" inscritas sobre su pecho. El rostro recortado de la mujer la vuelve irreconocible, lo que enfatiza la cruel degradación que ella y tantas otras mujeres Negras esclavizadas padecieron. Si bien se le exige que prepare y sirva las comidas, ella no es lo suficientemente buena para consumir el mismo tipo de alimentos, insinuando a su vez que su único valor es el trabajo manual que lleva a cabo en la cocina de una mujer blanca sureña. Lejos de ser reliquias del pasado, las caricaturas de cocineras esclavizadas como Aunt Jemima solo han comenzado a ser retiradas de los estantes de los supermercados estadounidenses recientemente.[6]

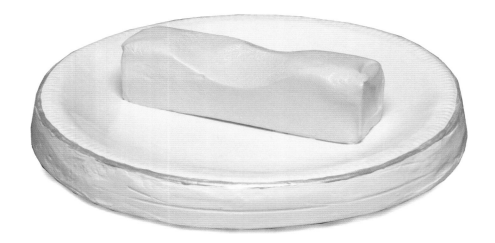

MALIA JENSEN (American/estadounidense, b./n. 1966)
Butterscape/Escapemantequilla, edition/edición 1/3, 2008
Plaster of Paris and enamel/Yeso de Paris y esmalte
1¾ × 8 × 8 in. (4.5 × 20.3 × 20.3 cm)

FOOD FOR THOUGHT

Some artists provoke new lines of inquiry by divorcing food from its edibility. Whether by altering its texture, changing its function, or placing it in a novel environment, the food transforms into a new object with a fresh perspective.

The multimedia artist Malia Jensen creates works that ebb and flow between the domestic and natural realms, sometimes blurring the two environments. Through her work, she transforms the banal into the provocative, as she explores texture, form, and natural life cycles. At first, *Butterscape* (2008) appears to be a straightforward representation of a stick of butter. However, the butter has an indentation, as if someone has gently mushed it with the heel of their palm. This suggests a soft texture, yet the sculpture is made from hard plaster. Furthermore, Jensen's titling contradicts the representation of the butter as foodstuff and instead invites the viewer to contemplate its meaning beyond its edibility.

Joseph Beuys's *Capri Battery* (1985) features a yellow light bulb plugged into an actual lemon, provoking questions surrounding the delicate balance of nature and technology. The piece suggests that the lemon is providing the energy for

ALIMENTO PARA EL PENSAMIENTO

Algunes artistas suscitan nuevas líneas de investi-gación al divorciar el alimento de su posibilidad de ser comestible. Ya sea alterando su textura, cam-biando su función o ubicándola en un entorno nove-doso, la comida se transforma en un objeto diferente con una nueva perspectiva.

La artista multimedia Malia Jensen crea piezas que fluyen entre el ámbito doméstico y el ámbito natu-ral, a veces desdibujando ambos ambientes. Con su trabajo, Jensen transforma lo banal en provocador, mientras explora texturas, formas y ciclos de vida naturales. Inicialmente, *Escapemantequilla* (2008) parece ser una simple representación de una barra de mantequilla. Sin embargo, la mantequilla tiene una hendidura, como si alguien la hubiera aplastado suavemente con la palma de su mano. Esto insinúa una textura suave, pero la escultura está hecha de yeso duro. Además, el título de Jensen contradice la representación de la mantequilla como alimento y, en vez, invita al observador a contemplar su significado más allá de si es comestible o no.

Batería Capri (1985) de Joseph Beuys es un foco amarillo enchufado a un limón real que provoca preguntas sobre el delicado equilibrio entre natu-raleza y tecnología. La pieza sugiere que el limón provee de energía al foco, quizás aludiendo a la

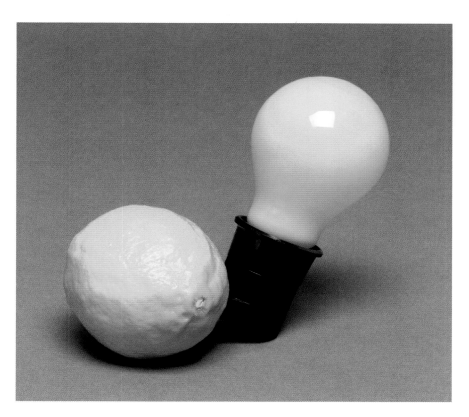

JOSEPH BEUYS (German/alemán, 1912–1986)
Capri Battery/Batería Capri, edition/edición AP 49/50, 1985
Light bulb (Mazda), plug socket, and exchangeable lemon/
Bombilla (Mazda), enchufe y limón intercambiable
6 × 4½ × 4 in. (15.2 × 11.4 × 10.2 cm)

the light bulb, perhaps alluding to the idea that all human advances are in some way reliant on nature as a resource. The comparable color and size of the two objects provide a sense of visual unity, but the lemon's perishable nature warns of the earth's limited capacity to survive overexploitation in the name of human achievement.

Throughout his lengthy career and long before the invention of the smartphone, the conceptual artist John Baldessari routinely questioned how meaning is created by disrupting ordinary images through cropping, overlapping, or juxtapositions with text. His clever *Emoji* series (2018) brings these same ideas into the twenty-first century. As common symbols used in digital communications, emojis have become signifiers in their own right. Baldessari adds a sense of jest by enlarging these pictures and adding captions that do not necessarily correspond to the viewer's understanding of the emoji. Detached from their digital platform, the emojis' subjectivity of meaning must now be considered.

noción de que todos los avances humanos dependen de alguna manera de la naturaleza como recurso. La similitud del color y del tamaño de los dos objetos proporciona una sensación de unidad visual, pero la naturaleza perecedera del limón advierte de la limitada capacidad que tiene la tierra de sobrevivir a la sobreexplotación hecha en nombre del progreso humano.

A lo largo de su extensa carrera y mucho antes de la invención del teléfono inteligente, el artista conceptual John Baldessari cuestionó rutinariamente cómo se crea significado al irrumpir imágenes ordinarias mediante recortes, superposiciones o yuxtaposiciones con texto. Su ingeniosa serie *Emoji* (2018) trae estas mismas ideas al siglo XXI. Como símbolos utilizados comúnmente en las comunicaciones digitales, los emojis se han convertido en significantes por sí mismos. Baldessari agrega un giro humorístico al ampliar estas imágenes y agregar leyendas que no necesariamente corresponden al entendimiento del emoji por parte del espectador. Desprendidos de su plataforma digital, la subjetividad del significado de los emojis ahora debe de ser considerada.

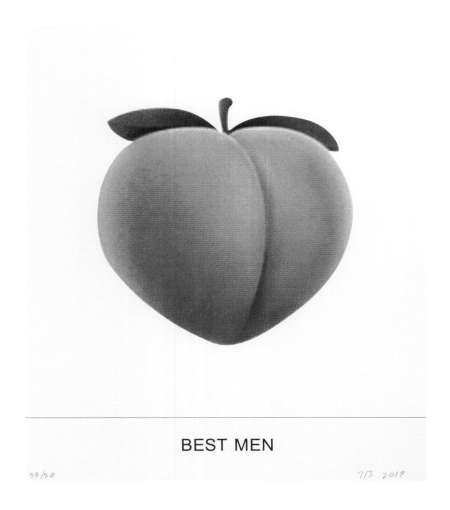

BEST MEN

33/50 7/3 2017

JOHN BALDESSARI (American/estadounidense, 1931–2020)
BEST MEN/PADRINOS, edition/edición 35/50, 2018
Screenprint/Serigrafía
33 × 28 in. (83.8 × 71.1 cm)

EYE CANDY

Chris Antemann's porcelain sculptures blur the boundaries between the temptations of food and flesh. Inspired by the fashions, flirtatious subjects, and porcelain medium of eighteenth-century rococo decorative arts, Antemann creates her porcelains with a contemporary twist. *Covet* (2013) depicts a small banquet table, filled with delectable pastries and fruits. Somewhat amusingly, the main dish is a woman, crouched on all fours in the center of the table. Although she has taken a humorous approach, Antemann is seriously questioning society's construction of gender roles and expectations of behavior.

Katherine Ace's *Cupid and Psyche with Cut Apple* is more than just a painting of visual delight. A papaya and a halved apple rest on a silver dish,

UN REGALO PARA LA VISTA

Las esculturas de porcelana de Chris Antemann difuminan los límites entre las tentaciones de la comida y aquellas de la carne. Inspirada en las modas, en los temas de coquetería y en la porcelana como medio de las artes decorativas rococó del siglo XVIII, Antemann crea sus porcelanas con un toque contemporáneo. *Deseo* (2013) muestra una pequeña mesa de banquete, llena de deliciosos pastelitos y frutas. De manera un tanto provocadora, el platillo principal es una mujer a gatas en el centro de la mesa. Aunque ha adoptado un enfoque humorístico, Antemann está cuestionando seriamente la construcción social de los roles de género y de las expectativas de comportamiento.

Cupido y Psique con manzana cortada de Katherine Ace es más que una simple pintura de deleite visual. Una papaya y una manzana cortada por la mitad

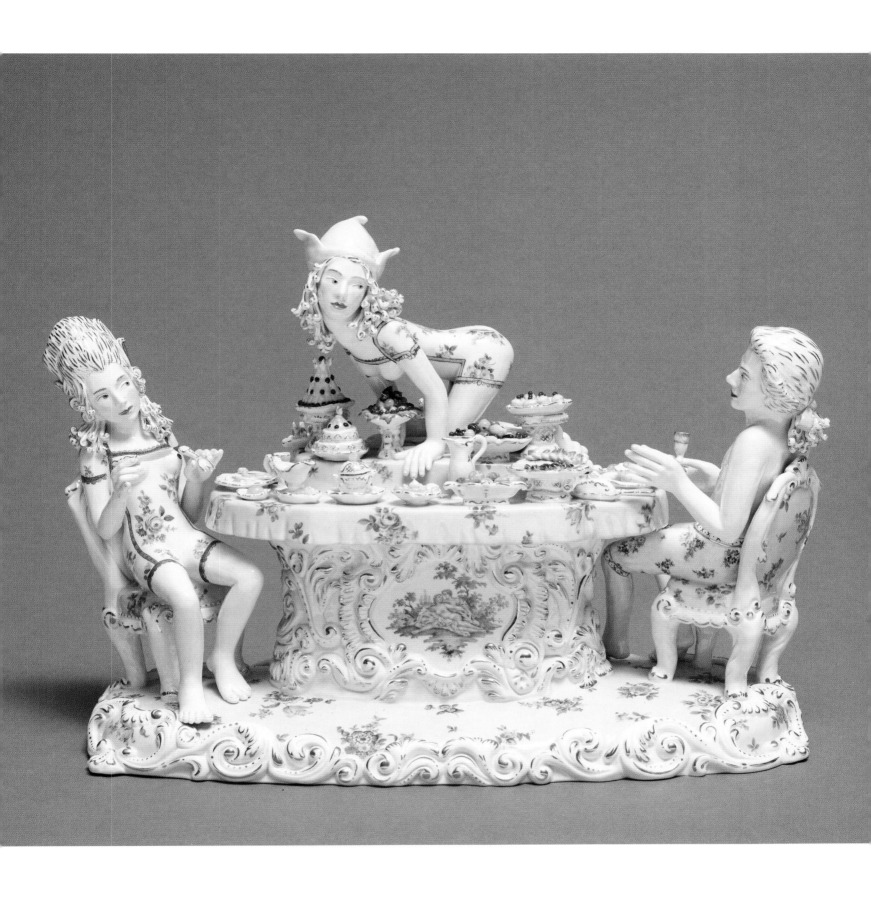

CHRIS ANTEMANN (American/estadounidense, b./n. 1970)
Covet/Deseo, edition/edición 3/8, 2013
Meissen porcelain/Porcelana de Meissen
13¼ × 19 × 8 in. (33.7 × 48.3 × 20.3 cm)

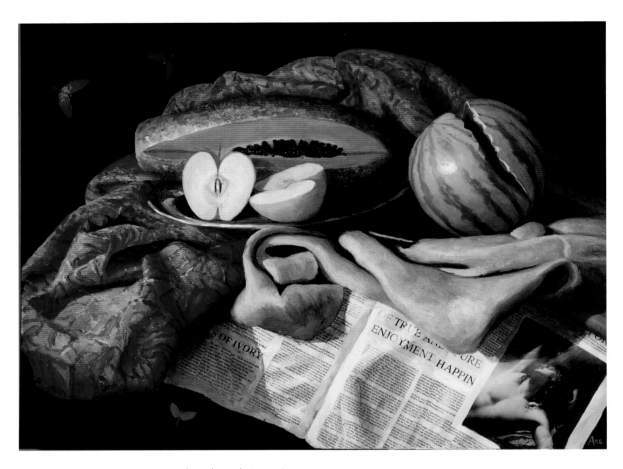

KATHERINE ACE (American/estadounidense, b./n. 1953)
Cupid & Psyche with Cut Apple/Cupido y Psique con manzana cortada, ca. 2010
Oil on canvas/Óleo sobre lienzo
30 × 40 in. (76.2 × 101.6 cm)

next to a watermelon that has cracked open. These fruits sit atop fabrics that reveal a newspaper featuring an image of a reclining man. The title of the painting suggests this man is Cupid, likely at the moment in the myth when Psyche discovers that her nighttime lover is none other than the god of love himself. This painting, its enticing fruits combined with the ancient narrative, evokes an atmosphere of temptation through both bodily and gustatory indulgence.

Sherrie Wolf's *First Harvest* (2016) is a harmony of textures and colors. An overflowing vase of tulips sits atop a table, flanked on one side by a bowl of mandarin oranges and on the other by a partially peeled lemon, its rind coiling off the table. The bulk of the composition is filled with the luxurious sheen of purple and red fabrics that cascade to the ground, leading the viewer's eye

descansan sobre una bandeja de plata, junto a una sandía que se ha agrietado. Estas frutas están sobre telas que revelan un periódico con la imagen de un hombre reclinado. El título de la pintura sugiere que el hombre es Cupido, probablemente en el momento del mito en el que Psique descubre que su amante nocturno es nada más y nada menos que el mismo dios del amor. La pintura, sus frutas sugestivas combinadas con la antigua narrativa, evoca una atmósfera de tentación a través de la satisfacción tanto corporal como gustativa.

Primera cosecha (2016) de Sherrie Wolf es una armonía de texturas y colores. Un florero desbordado de tulipanes está sobre una mesa, flanqueado por un cuenco de mandarinas de un lado y del otro por un limón parcialmente pelado, con la cáscara enrollándose fuera de la mesa. La mayor parte de la composición está ocupada por el brillo lujoso de las telas morada y roja que caen en cascada al suelo y guían el

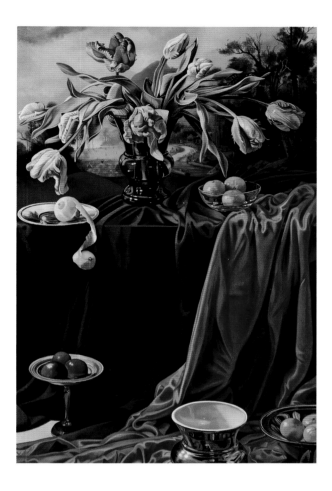

SHERRIE WOLF (American/estadounidense, b./n. 1952)
First Harvest/Primera cosecha, 2016
Oil on canvas/Óleo sobre lienzo
60 × 40 in. (152.4 × 101.6 cm)

to more fruit below. The objects in this painting spark the senses—one can almost feel the cool fabrics and smell the lemon. It is clearly a reference to European still life painting, a genre that flourished particularly during the seventeenth century.

Still lifes offered artists the opportunity to display their technical mastery and were often as symbolically complex as they were visually appealing.[7] They harbor insight into past aspirations, economies, social structures, and fears. For all of *First Harvest*'s beauty and apparent straightforwardness, there is also a sense of ambiguity. The floral and fruit arrangement is abruptly set against a pastoral scene, seemingly plucked from the past, of people working in a field, making this painting simultaneously a scene of luxury and labor.

ojo del observador a ver más frutas debajo. Los objetos en esta pintura despiertan los sentidos—casi se puede sentir la frescura de las telas y oler el limón. Es una clara referencia a la pintura de naturaleza muerta europea (o bodegones), un género que floreció durante el siglo XVII particularmente.

La pintura de naturaleza muerta le ofrecía a les artistas la oportunidad de mostrar su destreza técnica y, con frecuencia, eran tan complejas simbólicamente como llamativas visualmente.[7] Estas pinturas albergan un conocimiento perspicaz sobre las aspiraciones, las economías, las estructuras sociales y los miedos del pasado. A pesar de la belleza y evidente sencillez de *Primera cosecha*, también existe una sensación de ambigüedad. El arreglo floral y frutal está contrapuesto abruptamente a una escena pastoral, aparentemente arrancada del pasado, con personas que trabajan en un campo, haciendo de esta pintura una escena de lujo y de mano de obra simultáneamente.

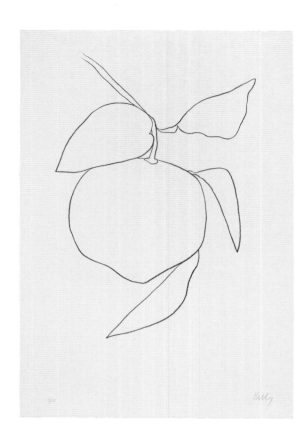

ELLSWORTH KELLY (American/estadounidense, 1923–2015)
Suite of Plant Lithographs: Grapefruit (Pamplemousse)/
Conjunto de litografías de plantas: Toronja (Pamplemousse),
edition/edición 7/75, 1964–65
Lithograph/Litografía
35⅜ × 24¼ in. (89.9 × 61.6 cm)

STILL LIFE

In contrast to Wolf's approach, the still lifes of Ellsworth Kelly and Donald Sultan walk a paradoxical boundary between naturalism and artifice. They are as minimal as they are complex; their subjects banal, yet simultaneously provocative. Although these works stem from botanical illustration and European still life traditions, Kelly and Sultan have moved those genres to a new level—one where a single object is elevated to a status worthy of its own monumental size and space.

In *Grapefruit* (1964–65), Kelly uses crisp contour lines to define the shape, whereas Sultan, in *Black Lemons* (1987), builds up form through layers of hazy mist. The play of positive and negative space and of solid mass versus contour line, signals differing artistic approaches of the artists. Yet their works are still connected in their ability to center the power and graphic appeal of black-and-white imagery.

NATURALEZA MUERTA

A diferencia del método de Wolf, los bodegones de Ellsworth Kelly y de Donald Sultan se encuentran en el paradójico límite entre naturalismo y artificio. Son tan mínimos como lo son complejos; sus temas son banales, pero a la vez provocadores. Aunque estas obras se derivan de la ilustración botánica y de las tradiciones de la naturaleza muerta europea, Kelly y Sultan han llevado esos géneros a un nuevo nivel— uno en el que un solo objeto es elevado a un estado digno de su propio tamaño y espacio monumentales.

En *Pamplemousse* (1964–65), Kelly emplea nítidas líneas de contorno para definir la forma, mientras que Sultan, en *Limones negros* (1987), construye la forma con capas de difusa neblina. El juego de espacio positivo y negativo y de masa sólida versus líneas de contorno, señala los distintos enfoques artísticos de les creadores. Sin embargo, sus obras se mantienen conectadas por su capacidad de enfocarse en el poder y en el atractivo gráfico de las imágenes en blanco y negro.

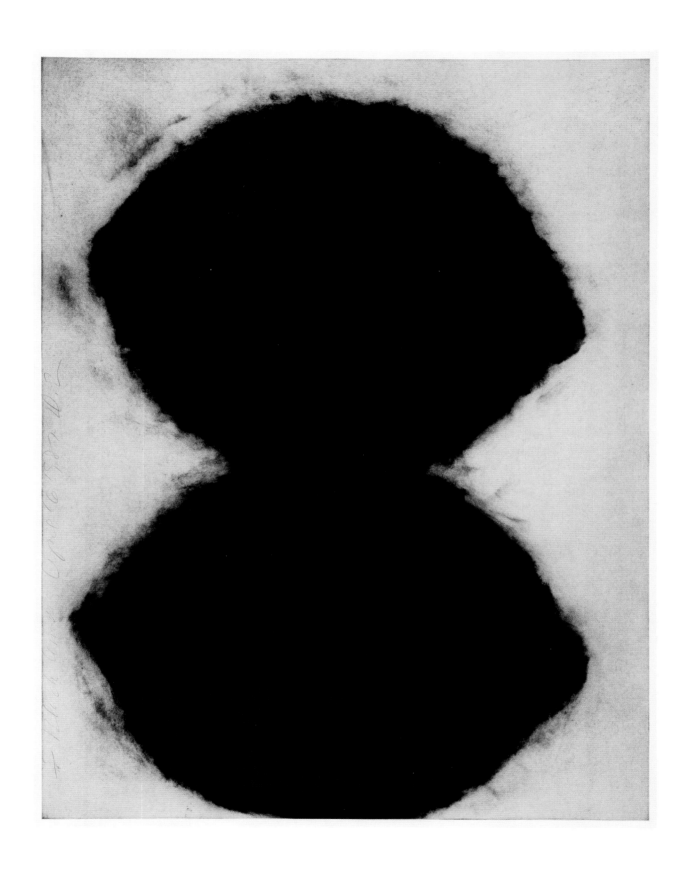

DONALD SULTAN (American/estadounidense, b./n. 1951)
Black Lemons/Limones negros, edition/edición 5/14, 1987
Aquatint etching/Grabado al aguatinta
62 × 47⅞ in. (157.5 × 121.6 cm)

ELIXIRS AND LIBATIONS

Where there is food in art, there is often drink, making beverages an important feature in the art of food. There is an added layer however, to the depiction of drinks that artists must consider. As Molly Kalkstein explains: "Liquids, of course, have no inherent shape of their own. Accordingly, artists have resorted to a variety of approaches in order to portray drinks and drinking."[8] As many works demonstrate, it is possible to represent the drink without the liquid itself.

One way to achieve this is by depicting a specific type of vessel, such as in Rachel Whiteread's *Squashed* (2010). This print depicts two sides of an old metal can. Due to its flattened nature, its function as vessel is removed, yet one can imagine the type of liquid it once held. Corporate logos are yet another way to signal a specific drink. Jasper Johns's *Untitled (Coca-Cola and Grid)* (1971) includes Coca-Cola's iconic logo. The familiar white script set against a red background stands in for the beverage itself, and immediately calls to mind the sweet, carbonated drink.

With the rise of smartphones and social media platforms, images of food are more pervasive than ever before. It is precisely because of this prevalence that it is worthy to pause the scrolling and reflect on our relationships with food, especially in light of the COVID-19 pandemic. From emptied grocery store shelves and shuttered restaurants to canceled celebrations and holidays; from the creation of home gardens to growing lines at food banks, rituals around food have changed quickly and dramatically. The works in

ELIXIRES Y LIBACIONES

Donde hay comida en el arte, con frecuencia hay bebidas, lo que hace de estas un aspecto importante del arte de la comida. Sin embargo, hay una capa adicional que les artistas deben de considerar en la representación de bebidas. Como lo explica Molly Kalkstein: "Los líquidos, por supuesto, no tienen una forma que les sea inherente. Consecuentemente, les artistas han recurrido a una variedad de métodos para retratar bebidas y el beber."[8] Como muchas obras lo demuestran, es posible representar la bebida sin el líquido mismo.

Una manera de lograr lo anterior es mostrando un tipo de recipiente en particular, como en *Aplastada* (2010) de Rachel Whiteread. Este grabado muestra los dos costados de una lata de metal vieja y aplastada. Por su estado aplanado, la función de la lata como recipiente es eliminada, pero el público puede imaginar el tipo de líquido que alguna vez contuvo. Los logotipos corporativos son otra forma de indicar una bebida específica. *Sin título (Coca-Cola y cuadrícula)* (1971) de Jasper Johns contiene el icónico logotipo de Coca-Cola. La conocida caligrafía blanca sobre el fondo rojo sustituye al líquido mismo e inmediatamente nos recuerda la bebida dulce y carbonatada.

Con el aumento de los teléfonos inteligentes y de las plataformas de redes sociales, las imágenes de comida son más ubicuas que nunca. Es precisamente por esta predominancia que vale la pena pausar la navegación en línea y reflexionar sobre nuestras relaciones con el alimento, especialmente ante la pandemia de COVID-19. Desde los anaqueles vacíos en los supermercados y los restaurantes cerrados hasta los días festivos y las celebraciones canceladas, desde la creación de huertos caseros hasta las largas filas en los bancos de alimentos, los rituales de y sobre la comida han cambiado rápida

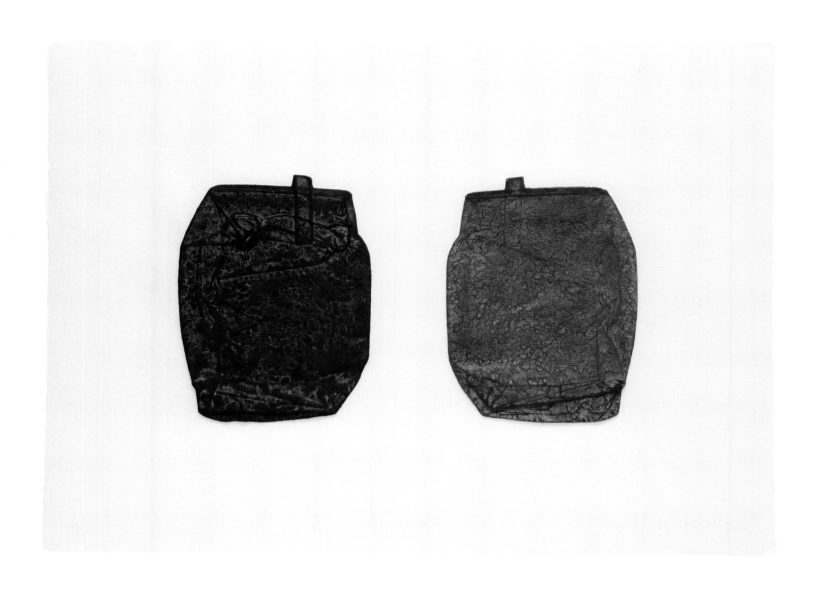

RACHEL WHITEREAD (British/británica, b./n. 1963)
Squashed/Aplastada, edition/edición 42/42, 2010
Mixografia print on handmade paper/Impresión Mixografía en
papel hecho a mano
27 x 37 in. (68.58 x 93.98 cm)

The Art of Food depict more than representations of sustenance. They share their ability to evolve as contemporary audiences view them through a new lens; they are rife with cultural significance and myriad meanings.

y dramáticamente. Las obras en *The Art of Food* son más que meras representaciones de sustento. Tienen en común la capacidad de evolucionar a medida que las audiencias contemporáneas las ven a través de una nueva lente; están llenas de valor cultural y cuentan con innumerables significados.

NOTES

1 Jean Anthelme Brillat-Savarin, *The Physiology of Taste: Or Meditations on Transcendental Gastronomy* (1825; New York: Vintage, 2009), 189–90. The epigraph is from 190.

2 For more on the evolution of Thanksgiving imagery in art, see Judith A. Barter, "Thanksgiving: The Great American Food Fest," in *Art and Appetite: American Painting, Culture, and Cuisine*, exh. cat. (Chicago: Art Institute of Chicago, 2013), 41–56.

3 Sarah Kelly Oehler, "Convenience: Pop, Production, and the Making of Art in the 1960s," in *Art and Appetite*, 215.

4 For more on Andy Warhol and animals, see Anthony E. Grudin, "Warhol's Animal Life," *Criticism* 56, no. 3 (Summer 2014): 593–622.

5 For more on food sovereignty, see Priscilla Settee and Shailesh Shukla, eds., *Indigenous Food Systems: Concepts, Cases, and Conversations* (Toronto: Canadian Scholars, 2020).

6 Kelley Fanto Deetz, *Bound to the Fire: How Virginia's Enslaved Cooks Helped Invent American Cuisine* (Lexington: University Press of Kentucky, 2017), 78.

7 Kenneth Bendiner, *Food in Painting: From the Renaissance to the Present* (London: Reaktion, 2004), 23.

8 Molly Kalkstein, "Elixirs and Libations: The Visual Art of Drinks and Drinking," exhibition label from *The Art of Food: Highlights from the Collections of Jordan D. Schnitzer and His Family Foundation*, University of Arizona Museum of Art, 2021.

NOTAS

1 Jean Anthelme Brillat-Savarin, *The Physiology of Taste: Or Meditations on Transcendental Gastronomy* (1825; Nueva York: Vintage, 2009), 189–90. El epígrafe es de la página 190.

2 Para más información sobre la evolución de imágenes en el arte sobre el día de Acción de Gracias, consultar: Judith A. Barter, "Thanksgiving: The Great American Food Fest," en *Art and Appetite: American Painting, Culture, and Cuisine*, cat. exp. (Chicago: Art Institute of Chicago, 2013), 41–56.

3 Sarah Kelly Oehler, "Convenience: Pop, Production, and the Making of Art in the 1960s," en *Art and Appetite*, 215.

4 Para más información sobre Andy Warhol y animales, consultar: Anthony E. Grudin, "Warhol's Animal Life," *Criticism* 56, no. 3 (Summer 2014): 593–622.

5 Para más información sobre soberanía alimentaria, consultar: Priscilla Settee y Shailesh Shukla, eds., *Indigenous Food Systems: Concepts, Cases, and Conversations* (Toronto: Canadian Scholars, 2020).

6 Kelley Fanto Deetz, *Bound to the Fire: How Virginia's Enslaved Cooks Helped Invent American Cuisine* (Lexington: University Press of Kentucky, 2017), 78.

7 Kenneth Bendiner, *Food in Painting: From the Renaissance to the Present* (Londres: Reaktion, 2004), 23.

8 Molly Kalkstein, "Elixirs and Libations: The Visual Art of Drinks and Drinking," ficha técnica de la exposición *The Art of Food: Highlights from the Collections of Jordan D. Schnitzer and His Family Foundation*, Museo de Arte de la Universidad de Arizona, 2021.

JASPER JOHNS (American/estadounidense, b./n. 1930)
Untitled (Coca-Cola and Grid)/Sin título (Coca-Cola y cuadrícula), edition/edición 53/66, 1971
Lithograph/Litografía
39 × 29½ in. (99.1 × 74.9 cm)

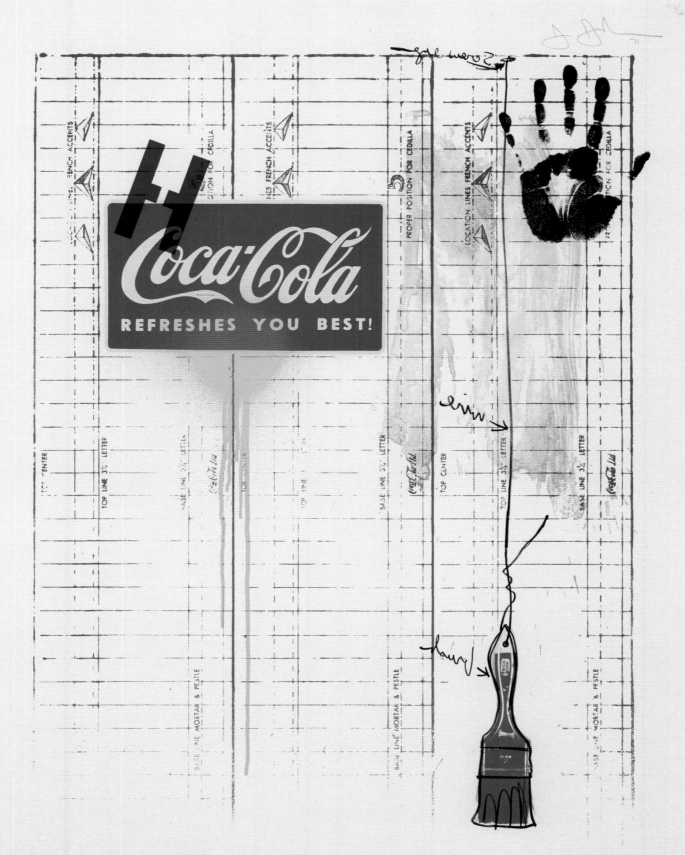

Food serves as a conduit for human interaction. Whether a simple lunch between friends or a feast among many, the act of acquiring, preparing, and eating food links people to one another. Food also has an effect on the landscape—from rural farms to urban restaurants, food is visually manifested in our daily surroundings.

Eating is a culturally determined practice that is subject to unique and evolving rituals. Social conventions and menus are dependent on the occasion, location, and company. A diner lunch implies a quick, casual bite, whereas a wedding banquet signals a more formal, yet festive, meal. Despite the difference in ritual, each of these events is communal, where the act of sharing food brings people together.

La comida sirve como un canal para la interacción humana. Ya sea un simple almuerzo con amistades o un banquete con muches participantes, el acto de adquirir, preparar y comer alimento crea vínculos entre las personas. La comida también tiene un efecto en el paisaje—de las granjas rurales a los restaurantes urbanos, la comida se manifiesta visualmente en nuestros entornos diarios.

El comer es una práctica condicionada culturalmente que está sujeta a rituales únicos y en evolución. Las convenciones sociales y los menús dependen de la ocasión, ubicación y compañía. Un almuerzo en la lonchería supone un pequeño bocado casual, mientras que un banquete de bodas indica una comida más formal, aunque festiva. A pesar de la diferencia en el ritual, cada uno de estos eventos es comunal, donde el acto de compartir alimento une a las personas.

COMMUNITY/
COMUNIDAD

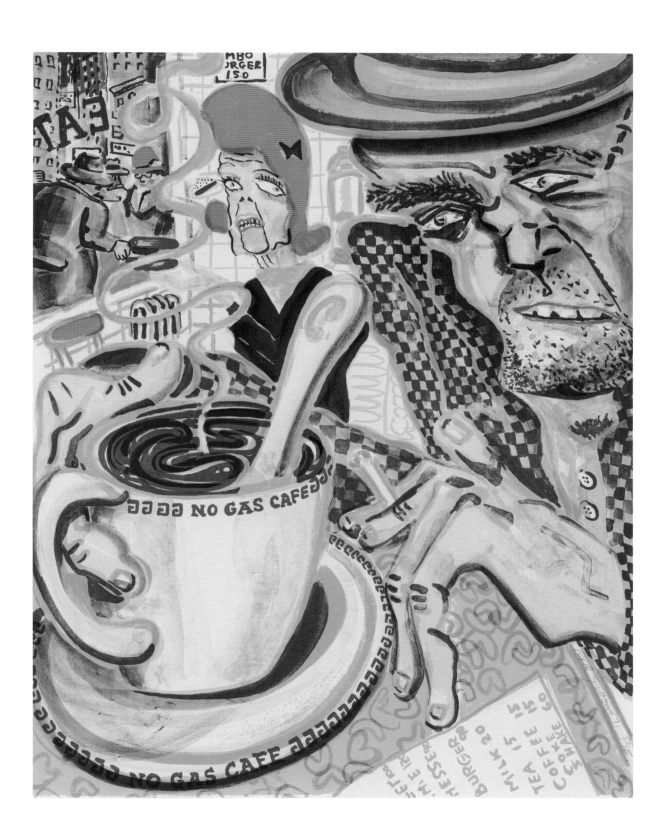

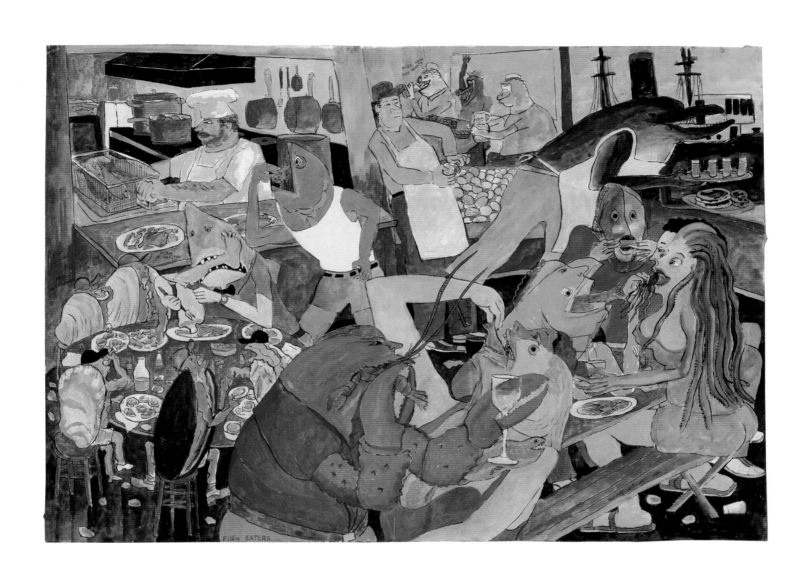

WARRINGTON COLESCOTT (American/estadounidense,
1921–2018)
Fish Eaters/Comedores de pescados, 1986
Watercolor/Acuarela
21¾ × 30½ in. (55.3 × 77.5 cm)

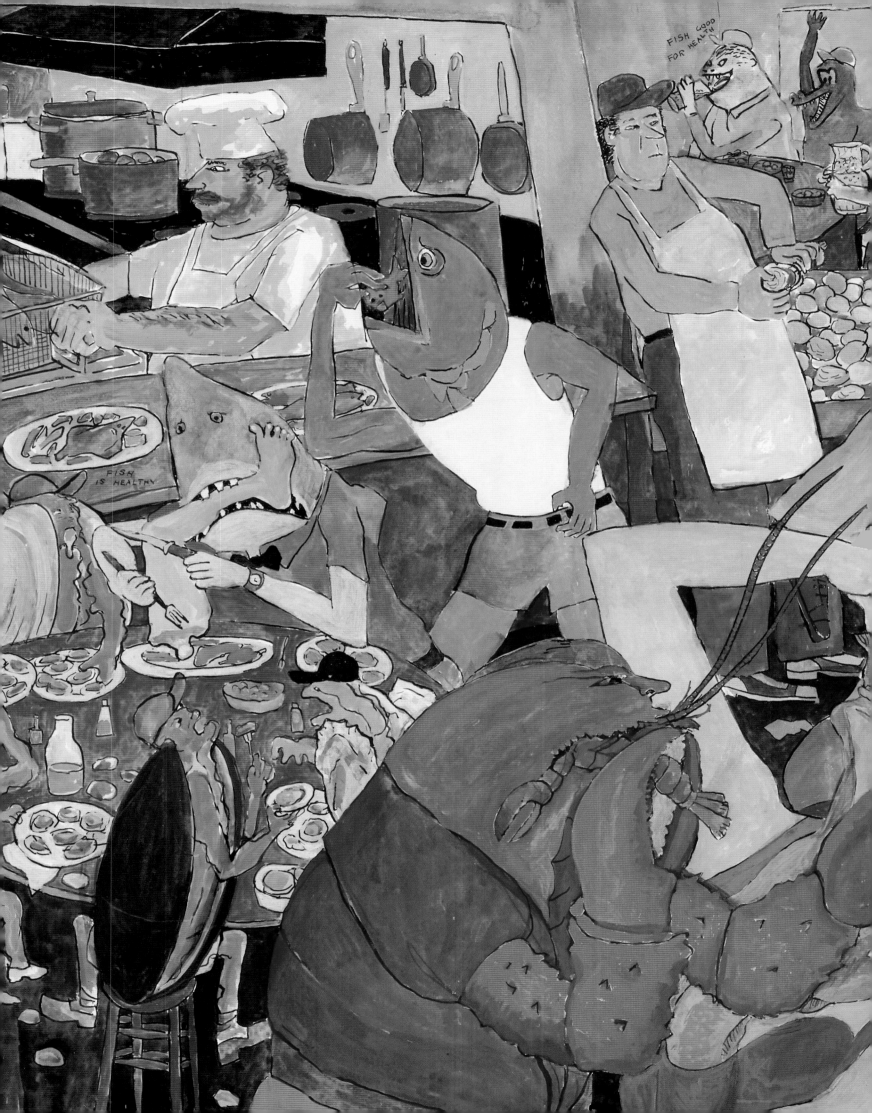

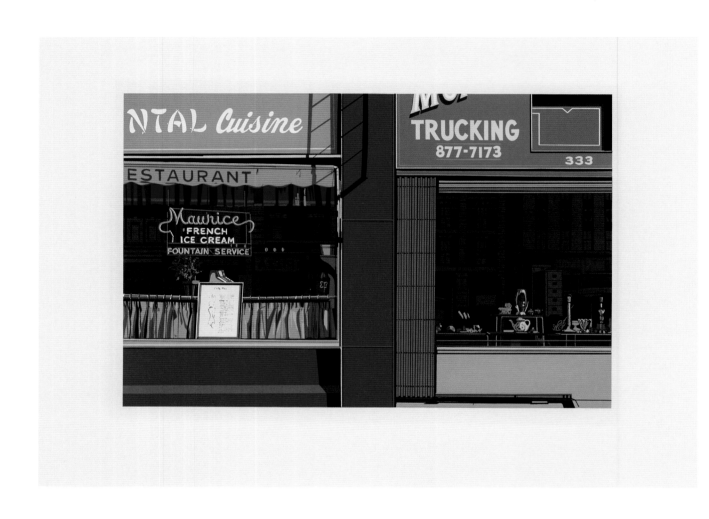

RICHARD ESTES (American/estadounidense, b./n. 1936)
Urban Landscapes I: Oriental Cuisine/Paisajes urbanos I: Cocina oriental, edition/edición 29/75, 1972
Screenprint/Serigrafía
19⅝ × 27½ in. (49.9 × 69.9 cm)

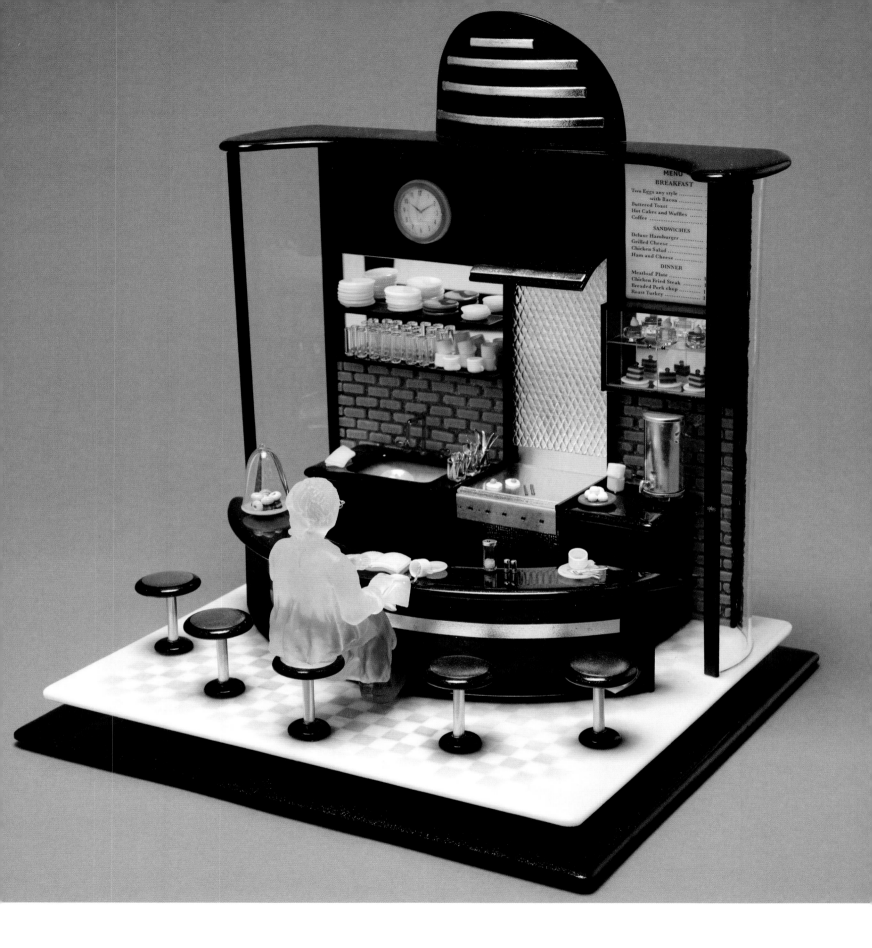

EMILY BROCK (American/estadounidense, b./n. 1945)
Diner Story/Relato en la cafetería, 2011
Kiln-worked, cast, and lampworked glass/Vidrio trabajado en
horno, fundido y con soplete
17 × 15 × 13 in. (43.2 × 38.1 × 33 cm)

Within the image, the menu reads:

MENU
BREAKFAST
Two Eggs any style
with Bacon
Buttered Toast
Hot Cakes and Waffles
Coffee

SANDWICHES
Deluxe Hamburger
Grilled Cheese
Chicken Salad
Ham and Cheese

DINNER
Meatloaf Plate
Chicken Fried Steak
Breaded Pork chop
Roast Turkey

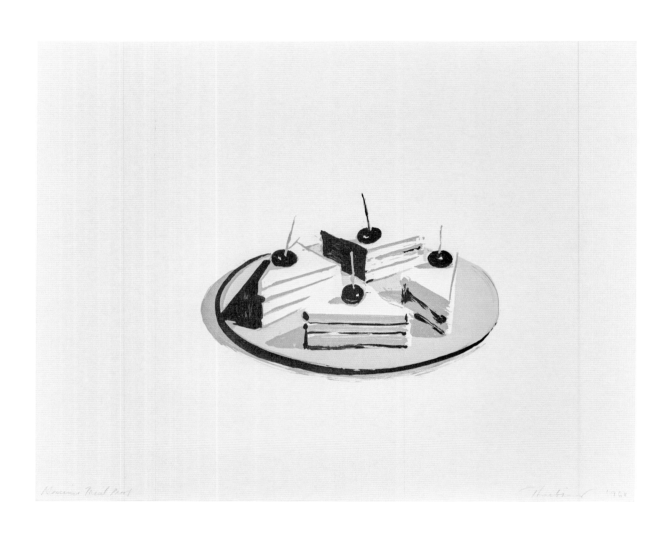

WAYNE THIEBAUD (American/estadounidense, b./n. 1920)
Sandwich/Sándwich, unique proof/prueba única, 1968
Linocut/Linograbado
17½ × 22 in. (44.5 × 55.9 cm)

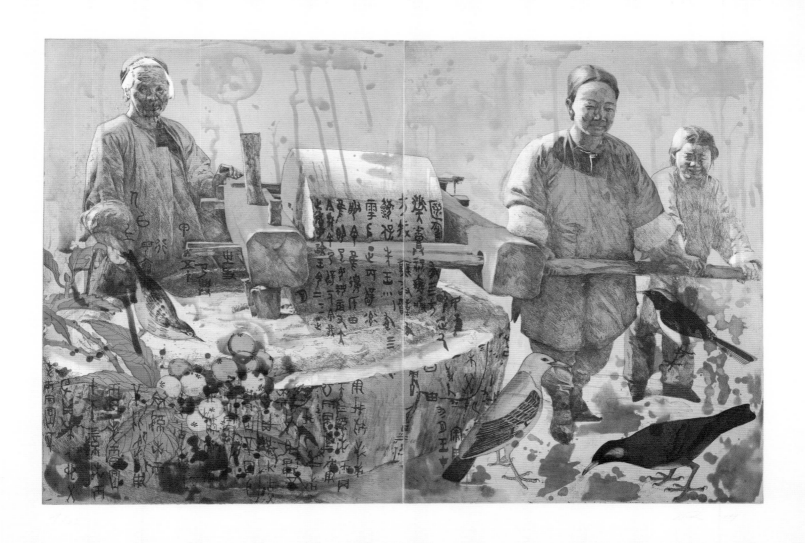

HUNG LIU (American, b. China/estadounidense, n. China, 1948–2021)
Women Working: Millstone/Mujeres trabajando: Muela, edition/ edición 29/35, 1999
Color softground and spitbite aquatint etching with scrape and burnish/Aguafuerte en color y grabado al aguatinta con raspado y bruñido
40¾ × 54½ in. (103.5 × 138.4 cm)

What do we actually know about the food we eat—where it originated, what it is made of, how it was transported? Ships, trains, and trucks convey food so that it is readily available at grocery stores and restaurants. Preservation technologies such as canning, refrigeration, and preservatives make foods once deemed "exotic" or seasonal accessible, no matter the time of year. Many of the works here investigate the commercialization of food, depicting a supermarket setting or a fast-food hamburger. Some show how food has become branded merchandise, while others poke fun at the dichotomy between packaged food and "freshness." These conveniences cater to the busy lifestyles of many urban dwellers but also have the potential to create disconnects.

¿Qué sabemos realmente sobre el alimento que comemos? ¿De dónde viene, de qué está hecho, cómo fue transportado? Barcos, trenes y camiones transportan comida para que esté lista en supermercados y restaurantes. Tecnologías para la preservación como el enlatado, la refrigeración y los conservadores vuelven a los alimentos antes considerados como "exóticos" o de temporada accesibles sin importar la época del año. Muchas de las obras aquí investigan la comercialización de la comida representando una escena de supermercado o una hamburguesa de comida rápida. Algunas muestran cómo el alimento se ha vuelto mercancía de marca, mientras que otras se burlan de la dicotomía entre comida empaquetada y "frescura". Estas comodidades satisfacen los estilos de vida ocupados de les urbanitas, pero también tienen el potencial de crear desconexiones.

DISSOCIATION/
DISOCIACIÓN

ROBERT GOBER (American/estadounidense, b./n. 1954)
Untitled/Sin título, edition/edición 63/75, 1993–94
Photolithograph/Fotolitografía
12¼ × 12 in. (31.1 × 30.5 cm)

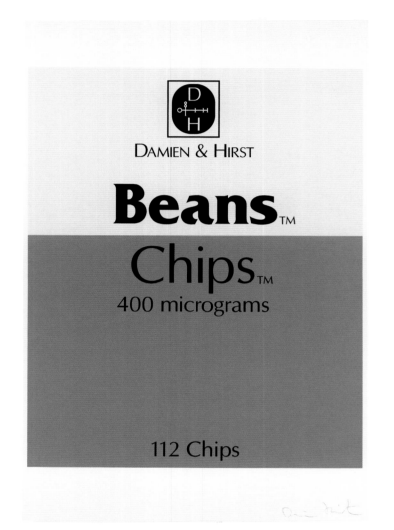

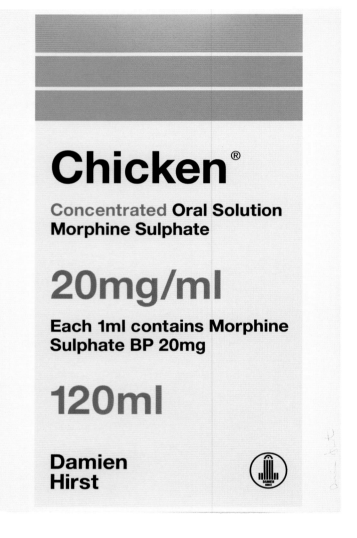

DAMIEN HIRST (British/británico, b./n. 1965)

The Last Supper: Beans, Chips/La última cena: frijoles, papas fritas,
edition of/edición de 150, 1999
Screenprint/Serigrafía
60 × 40 in. (152.4 × 101.6 cm)

The Last Supper: Chicken/La última cena: pollo, edition of/
edición de 150, 1999
Screenprint/Serigrafía
60 × 40 in. (152.4 × 101.6 cm)

The Last Supper: Corned Beef/La última cena: carne en conserva,
edition of/edición de 150, 1999
Screenprint/Serigrafía
60 × 40 in. (152.4 × 101.6 cm)

The Last Supper: Cornish Pasty, Peas/La última cena: pastel de
Cornualles, chícharos, edition of/edición de 150, 1999
Screenprint/Serigrafía
60 × 40 in. (152.4 × 101.6 cm)

DAMIEN HIRST (British/británico, b./n. 1965)

The Last Supper: Dumpling/La última cena: dumpling,
edition of/edición de 150, 1999
Screenprint/Serigrafía
40 × 60 in. (101.6 × 152.4 cm)

30 Tablets

Meatballs

Hirst

150mg

Each film-coated tablet contains
150mg moclobemide

Use only as directed by a physician

KEEP OUT OF REACH
OF CHILDREN

Store in a dry place

GRAVY

PL0031/0275 PA 50/81/2

Hirst Products Limited
Welwyn Garden City England

Mushroom™

**30 tablets
Pyrimethamine
Tablets BP**

25mg

PIE

HirstDamien

The Last Supper: Meatballs/La última cena: albóndigas,
edition of/edición de 150, 1999
Screenprint/Serigrafía
60 × 40 in. (152.4 × 101.6 cm)

The Last Supper: Mushroom Pie/La última cena: pastel de
champiñones, edition of/edición de 150, 1999
Screenprint/Serigrafía
60 × 40 in. (152.4 × 101.6 cm)

Omelette ™
ondansetron

tablets 8mg

Each tablet contains
8mg ondansetron
as ondansetron hydrochloride dihydrate
Also contains lactose and maize starch

10 tablets

HirstDamien

Salad ™ tablets
Lamivudine

Each coated tablet contains
lamivudine 150mg

60 tablets

HirstDamien

DAMIEN HIRST (British/británico, b./n. 1965)

The Last Supper: Omelette/La última cena: omelette,
edition of/edición de 150, 1999
Screenprint/Serigrafía
60 × 40 in. (152.4 × 101.6 cm)

The Last Supper: Salad/La última cena: ensalada,
edition of/edición de 150, 1999
Screenprint/Serigrafía
60 × 40 in. (152.4 × 101.6 cm)

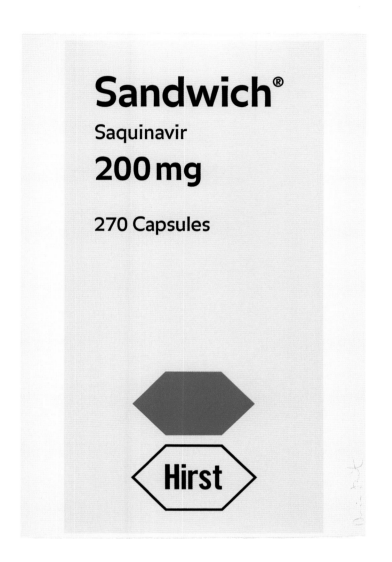

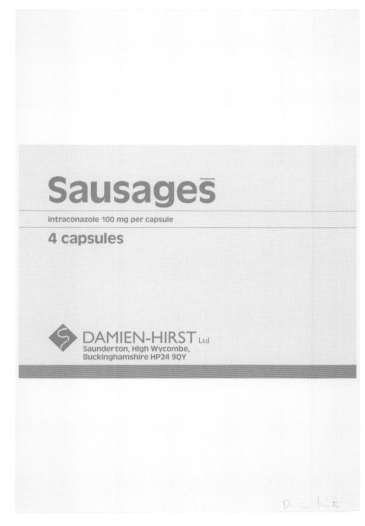

The Last Supper: Sandwich/La última cena: sándwich,
edition of/edición de 150, 1999
Screenprint/Serigrafía
60 × 40 in. (152.4 × 101.6 cm)

The Last Supper: Sausages/La última cena: salchichas,
edition of/edición de 150, 1999
Screenprint/Serigrafía
60 × 40 in. (152.4 × 101.6 cm)

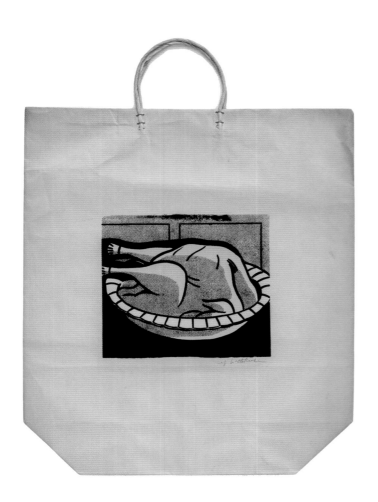

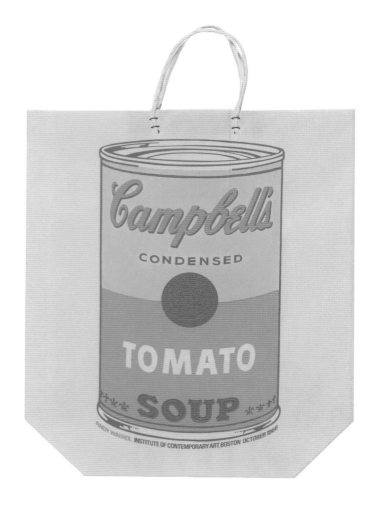

ROY LICHTENSTEIN (American/estadounidense, 1923–1997)
Turkey Shopping Bag/Bolsa de la compra con pavo, from an edition
of approx. 125/de una edición de 125 aprox., 1964
Screenprint on wove paper bag/Serigrafía sobre bolsa de papel
uniforme
19⁵⁄₁₆ × 17¹⁄₁₆ in. (49.1 × 43.3 cm)

ANDY WARHOL (American/estadounidense, 1928–1987)
Campbell's Soup Can (Tomato)/Lata de sopa Campbell (tomate),
unlimited edition/edición ilimitada, 1966
Screenprint on paper shopping bag/Serigrafía en una bolsa de
papel para la compra
23⁷⁄₈ × 17 in. (60.6 × 43.2 cm)

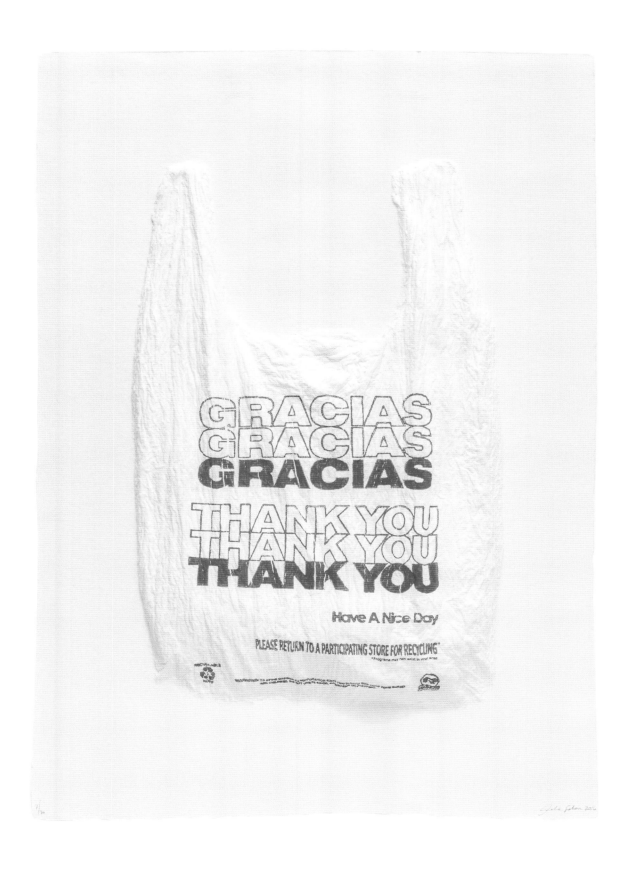

ANALÍA SABAN (Argentinian/argentina, b./n. 1980)
GRACIAS GRACIAS GRACIAS THANK YOU THANK YOU THANK
YOU Have a Nice Day Plastic Bag/ Bolsa de plástico GRACIAS
GRACIAS GRACIAS THANK YOU THANK YOU THANK YOU Que
tenga un buen día, edition/edición 7/20, 2016
Mixografia print on handmade paper/Impresión Mixografía en
papel hecho a mano
28½ × 20 × 1½ in. (72.4 × 50.8 × 3.8 cm)

All human beings are dependent on food and nourishment to survive. Despite this shared necessity, or perhaps because of it, food control is a particularly effective means to prescribe gender roles, construct a social hierarchy, or subjugate a culture.

Who has access to healthy and culturally relevant foods? What happens to a community when it is deprived of its traditional foodways? The works in this section of the exhibition interrogate these issues and lay bare the effects of colonialist and capitalist structures. These works invite questioning and understanding of where the power in food access lies and why this basic necessity for survival is abundant for some while scarce for others.

Todos los seres humanos dependen del alimento y de la nutrición para sobrevivir. A pesar de esta necesidad compartida, o tal vez a causa de ella, el control alimentario es un medio particularmente efectivo para prescribir roles de género, para construir una jerarquía social, o para subyugar a una cultura.

¿Quién tiene acceso a alimentos saludables y culturalmente relevantes? ¿Qué le pasa a una comunidad cuando se le priva de sus prácticas alimentarias? Las obras en esta sección de la exposición interrogan estos temas y exponen los efectos de las estructuras colonialistas y capitalistas. Estas obras invitan al cuestionamiento y entendimiento de dónde está el poder sobre el acceso al alimento y por qué esta necesidad básica para la sobrevivencia es abundante para algunas personas y escaza para otras.

CONTROL/
CONTROL

NEAL AMBROSE-SMITH (Native American, Salish-Kootenai, Métis-Cree, Sho-Ban/nativo norteamericano, Salish-Kootenai, Métis-Cree, Sho-Ban, b./n. 1966)
The World According to Monsanto/El mundo según Monsanto, edition/edición 29/92, 2014
Relief print/Grabado en relieve
10 × 8 in. (25.4 × 20.3 cm)

(following pages/siguientes páginas) ENRIQUE CHAGOYA (American, b. Mexico/estadounidense, n. México, 1953)
The Enlightened Savage/El salvaje ilustrado, edition/edición 14/40, 2002
Digital pigment prints on paper wrapped around cans with silkscreened cardboard box/Impresiones digitales de pigmentos sobre papel envuelto en unas latas con caja de cartón serigrafiada
(a–j): 16 × 14 × 5 in. (40.6 × 35.6 × 12.7 cm), box (k): 5 × 16 × 7 in. (12.7 × 40.6 × 17.8 cm)

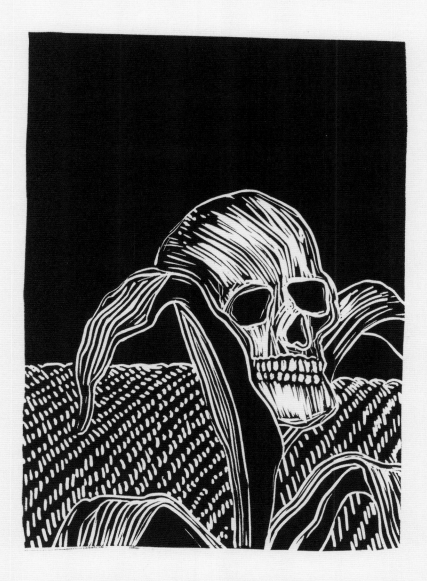

The world according to Monsanto, Neal Ambrose-Smith
Salish, Confederated Salish and Kootenai Nation
(descendant)

IF YOU'RE CONSIDERED USELESS,
NO ONE WILL FEED YOU ANYMORE.

JENNY HOLZER (American/estadounidense, b./n. 1950)
Survival Series: If You're Considered Useless No One Will Feed You Anymore/Serie de supervivencia: si se te considera inútil nadie te alimentará más, edition/edición 3/10, 1983–84
Cast aluminum plaque with black paint/Placa de aluminio fundido con pintura negra
3 × 10 × 1/8 in. (7.6 × 25.4 × .32 cm)

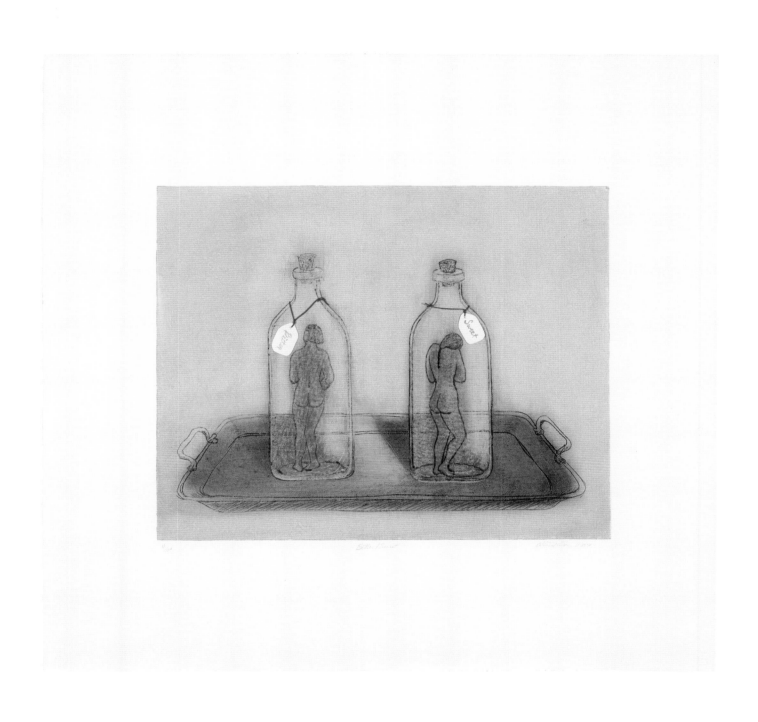

ALISON SAAR (American/estadounidense, b./n. 1956)
Bitter/Sweet/Amargo/Dulce, edition/edición 4/20, 2004
Etching and chine collé, hand-inked tags and string/Aguafuerte y
chine collé, etiquetas entintadas a mano y cuerda
28 × 29½ in. (71.1 × 74.9 cm)

The works in this section take the subject of food to conceptual levels, using depictions of food as catalysts for new conversations. Some of these artists use food as a medium, removing its edible nature and function as sustenance. Other works are more metaphorical in meaning, where the depictions of food signal a new connotation beyond eating. The viewer is encouraged to consider the relationship between the material and the subject. Some pieces are provocative in form yet elusive in meaning.

Las obras en esta sección llevan el tema de la comida a niveles conceptuales utilizando las representaciones de alimento como catalizadoras de conversaciones nuevas. Algunes de les artistas emplean la comida como medio, retirándole su carácter comestible y su función como sustento. Otras obras son más metafóricas en su significado, donde las representaciones de alimento indican una connotación nueva más allá del comer. El público está alentado a considerar la relación entre el material y el tema. Algunas obras son provocativas en su forma, pero imprecisas en su significado.

FOOD FOR THOUGHT/
ALIMENTO PARA EL PENSAMIENTO

JOHN BALDESSARI (American/estadounidense, 1931–2020)

(top row, from left to right/fila de arriba, de izquierda a derecha)

AND ONE SARDINE/Y UNA SARDINA, edition/edición 35/50, 2018
Screenprint/Serigrafía
35½ × 28 in. (90.2 × 71.1 cm)

BEST MEN/PADRINOS, edition/edición 35/50, 2018
Screenprint/Serigrafía
33 × 28 in. (83.8 × 71.1 cm)

I HAVE AN ELEPHANT/TENGO UN ELEFANTE, edition/edición 35/50, 2018
Screenprint/Serigrafía
33 × 28 in. (83.8 × 71.1 cm)

(bottom row, from left to right/fila de abajo, de izquierda a derecha)

TRUFFLE BUTTER/MANTEQUILLA CON TRUFA, edition/edición 35/50, 2018
Screenprint/Serigrafía
32½ × 28 in. (82.6 × 71.1 cm)

WHISKEY IN THE JAR/WHISKY EN LA JARRA, edition/edición 35/50, 2018
Screenprint/Serigrafía
33 × 28 in. (83.8 × 71.1 cm)

YOGURT/YOGURT, edition/edición 35/50, 2018
Screenprint/Serigrafía
33¼ × 28 in. (81.9 × 71.1 cm)

SIXTEEN SALTINES

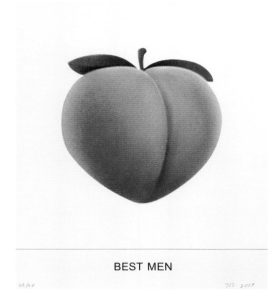

BEST MEN

XMAS CAKE

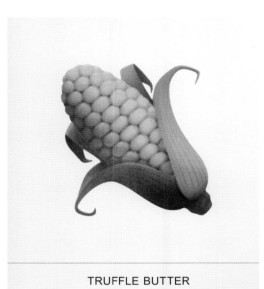

TRUFFLE BUTTER

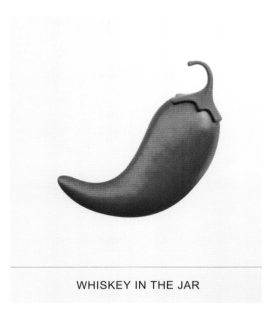

WHISKEY IN THE JAR

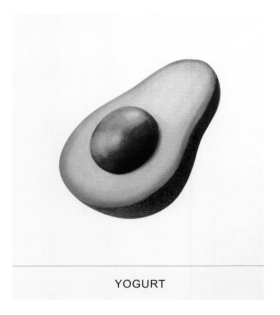

YOGURT

Food for Thought

Baked Beans in Tomato Sauce
Baked Beans in Tomato Sauce with Hamburgers
Baked Beans in Tomato Sauce with Frankfurters
Baked Beans with Tomato Sauce and Minced Beef
Baked Beans in Savory Sauce with Minced Beef
Baked Beans with Pork Sausages in Tomato Sauce
Curried Beans with Sultanas
Baconburgers
Beefburgers
Porkburgers
Pork'N'Beef
Curried Beef and Vegetables
Curried Lamb and Vegetables
Grapefruit Juice
Orange Juice
Pineapple Juice
Tomato Juice
Banana Dairy Desert
Caramel Dairy Desert
Chocolate Dairy Desert
Strawberry Dairy Desert
Egg Dairy Custard
Rice Pudding with Cream
Ground Rice Pudding with Cream
Macaroni Pudding with Cream
Sago Pudding with Cream
Semolina Pudding with Cream
Tapioca Pudding with Cream
Black Cherry Sponge Pudding
Chocolate Sponge Pudding
Golden Honey Sponge Pudding
Lemon Sponge Pudding
Mixed Fruit Sponge Pudding
Orange Sponge Pudding
Pineapple Sponge Pudding
Raspberry Sponge Pudding
Strawberry Sponge Pudding
Sultana Sponge Pudding
Treacle (Golden Syrup) Sponge Pudding
Tomato Ketchup
Apple Chutney
Wild Mustard Pickle
Piccalilli
Pickled Baby Beetroot
Sweet Pickle
Tomato Pickle
Mango Chutney
Pickled Onions
Silverskin Onions
Beetroot Salad
Cucumber Salad
Potato Salad
Vegetable Soup
French Dressing
Mayonnaise
Salad Cream
Apple Sauce
Ideal Sauce
Asparagus Soup
Beef Broth
Beef & Mushroom Soup
Beef Soup
Cheese & Onion Soup
Chicken, Celery & Rice Soup
Chicken & Ham Soup
Clear Chicken Broth
Country Broth
Cream of Celery Soup
Cream of Chicken Soup
Cream of Mushroom Soup
Cream of Tomato Soup
Cream of Turkey Soup
Cream of Vegetable Soup
Farmhouse Soup
Farmhouse Onion Soup
Farmhouse Turkey with Vegetable Soup
Golden Chicken & Leek Soup
Kidney Soup
Lentil Soup
Minestrone
Mulligatawny
Oxtail Soup
Pea & Ham Soup
Scotch Broth
Scottish Vegetable with Lentils
Spring Vegetable Soup
Thick Chicken Soup with Vegetable
Thick Vegetable & Beef Broth
Tomato & Lentil Soup
Vegetable Soup
Low Calorie Chicken Soup
Low Calorie Chicken with Vegetable Soup
Low Calorie Mushroom Soup
Low Calorie Oxtail Soup
Low Calorie Tomato Soup
Low Calorie Vegetable & Beef Soup
Ravioli with Savory Tomato Sauce
Macaroni Cheese
Spaghetti with Tomato & Cheese Sauce
Spaghetti Bolognese
Spaghetti Hoops with Tomato Sauce
Spaghetti Hoops in Beef Sauce
Cucumber Spread
Sandwich Spread
Savoury Onion Spread
Chicken & Mushroom Toast Topper
Curried Chicken Toast Topper
Ham & Cheese Toast Topper
Liver & Bacon Toast Topper
Mushroom & Bacon Toast Topper
Smoked Haddock & Cheese Toast Topper
Turkey & Ham Toast Topper
Veal & Ham Toast Topper
Malt Vinegar
Distilled Malt Vinegar

As soon as you left I was hungry. A plate of mashed potato
would do it, with milk and butter.
Or haddock
Kidnein
buckwheat maybe, or pigs' ears with marjoram.
Or even spinach would do
and custard.
Cod's roe – you don't need caviar every day –
dried cod
pigs' tails
tripe – I must cook you my tripe : dann wirst du verrückt
fish and chips and eels too
but raw pigs' ears is top of the bill tonight. Cooked for ½ hour
then cut in strips like spaghetti and laid on a pudding of peas
with a small onion cut in fine pieces stirred through it and a
bit of treacle
beggia and turnips and swedes and parsnips too.
(Ich bin ausgelaugt. I've lost 10 pounds. All I get to eat is pap.)
– Or soda bread with Irish butter and not too little black pudding
and a bit of pepper...achtrein with pepper, you know, but the best
brain is pig's brain, parsley, pepper with black bread,
that's fantastic.
What's the day tomorrow T – Wednesday. Tuesday is the best day
to buy brain because Monday is slaughter day and by Wednesday
the specialists have taken it all away.
(Ich bin so ausgelaugt. Ich falls flau).

The Vision of Mac Conglinne

Wheatlet son of Milklet,
Son of Juicy Bacon,
Is mine own name.

Honeyed Butter-roll
Is the man's name
 That bears my bag.

Haunch of Mutton
Is my dog's name,
 Of lovely leaps.

Lord, my love,
Sweetly smiles across
 the brose.

Cheese curds, my girl,
Goes round the spit,
 Fair is her face.

Corned Beef is my son
Who beams over a cloak,
 Enormous, of fat.

Savour of Savours
Is the name of my lady's maid :
 Morning early
 across Newmilk Lake she went.

Beef-lard, my steed,
an excellent stallion
 That increases studs;
A guard against toil
Is the saddle of cheese
 upon his back.

A large necklace of delicious cheesecurds
 Around his back;
His halter and traces all
 Of fresh butter.
(from the 6th century Irish).

JOSEPH BEUYS (German/alemán, 1912–1986)
Food for Thought/Alimento para el pensamiento, 1977
Lithograph/Litografía
34⅝ × 6½ in. (88 × 16.5 cm)

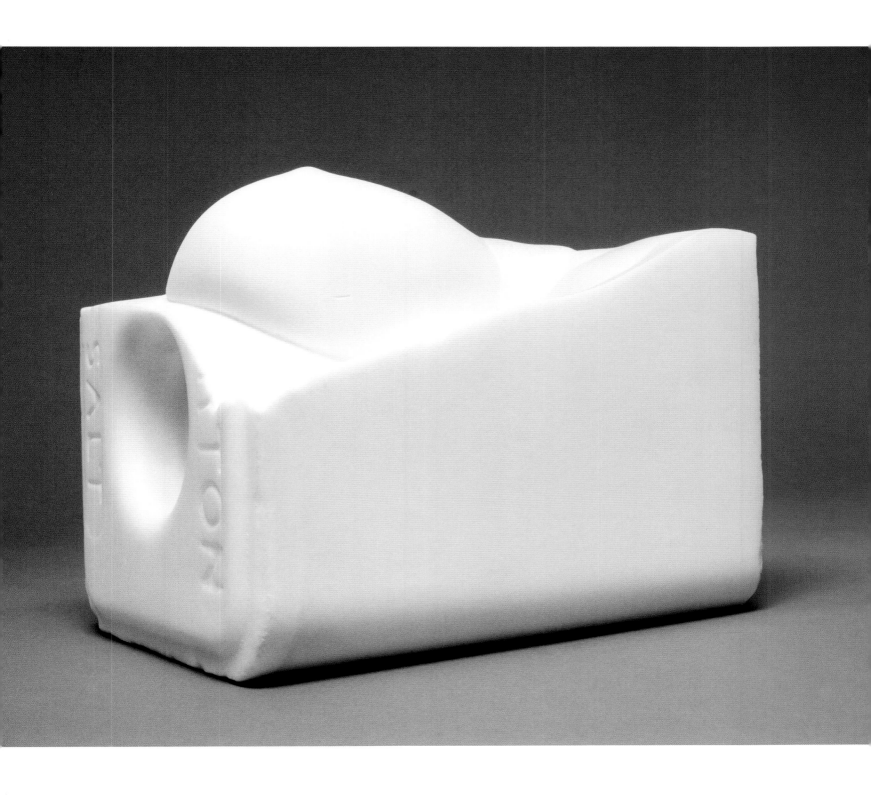

MALIA JENSEN (American/estadounidense, b./n. 1966)
Untitled 4 (salt lick)/Sin título 4 (bloque de sal para lamer), 2010
Carved salt lick/Bloque de sal para lamer tallado
9 × 9 × 11 in. (22.9 × 22.9 × 27.9 cm)

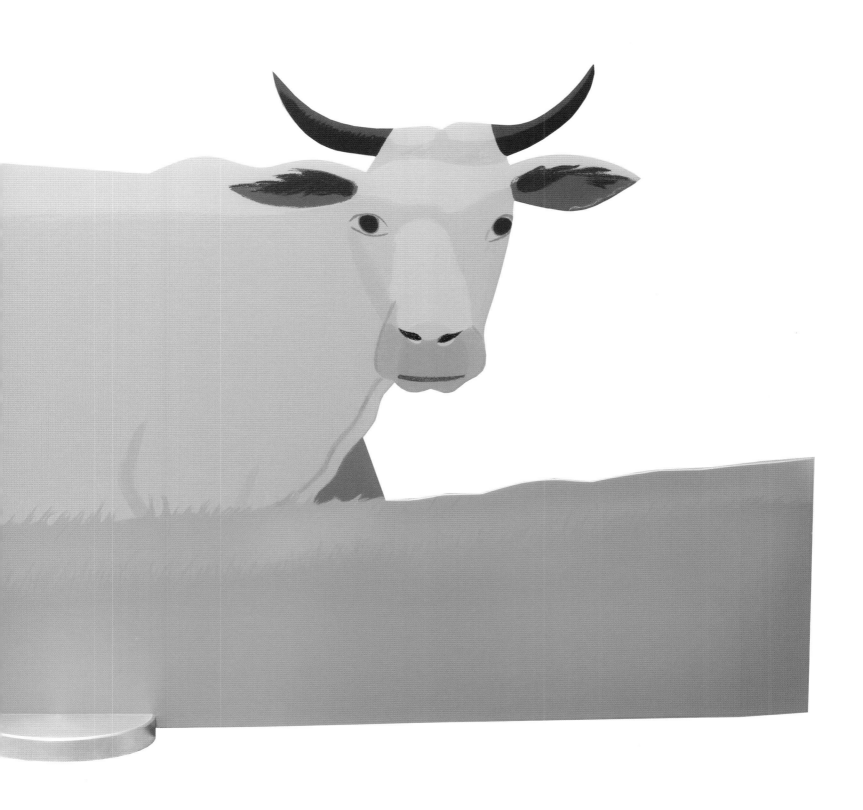

ALEX KATZ (American/estadounidense, b./n. 1927)
Cow (small)/Vaca (pequeña), edition/edición 48/99, 2004
Screenprint on aluminum/Serigrafía sobre aluminio
16 × 40¾ × 3¾ in. (40.6 × 103.5 × 9.5 cm)

ROY LICHTENSTEIN (American/estadounidense, 1923–1997)

(left, from top to bottom/izquierda, de arriba hacia abajo)

Bull Profile Series, Bull I/Serie de perfiles de toro, Toro I, edition/
edición 14/100, 1973
Screenprint, lithograph, linocut/Serigrafía, litografía, linograbado
27 × 35 in. (68.6 × 88.9 cm)

Bull Profile Series, Bull III/Serie de perfiles de toro, Toro III, edition/
edición 14/100, 1973
Screenprint, lithograph, linocut/Serigrafía, litografía, linograbado
27 × 35$\frac{1}{16}$ in. (68.6 × 89.1 cm)

Bull Profile Series, Bull V/Serie de perfiles de toro, Toro V, edition/
edición 14/100, 1973
Screenprint, lithograph, linocut/Serigrafía, litografía, linograbado
27$\frac{1}{16}$ × 35$\frac{1}{16}$ in. (68.7 × 89.1 cm)

(right, from top to bottom/derecha, de arriba hacia abajo)

Bull Profile Series, Bull II/Serie de perfiles de toro, Toro II, edition/
edición 14/100, 1973
Screenprint, lithograph, linocut/Serigrafía, litografía, linograbado
27 × 35 in. (68.6 × 88.9 cm)

Bull Profile Series, Bull IV/Serie de perfiles de toro, Toro IV, edition/
edición 14/100, 1973
Screenprint, lithograph, linocut/Serigrafía, litografía, linograbado
27 × 35 in. (68.6 × 88.9 cm)

Bull Profile Series, Bull VI/Serie de perfiles de toro, Toro VI, edition/
edición 14/100, 1973
Screenprint, lithograph, linocut/Serigrafía, litografía, linograbado
27 × 35 in. (68.6 × 88.9 cm)

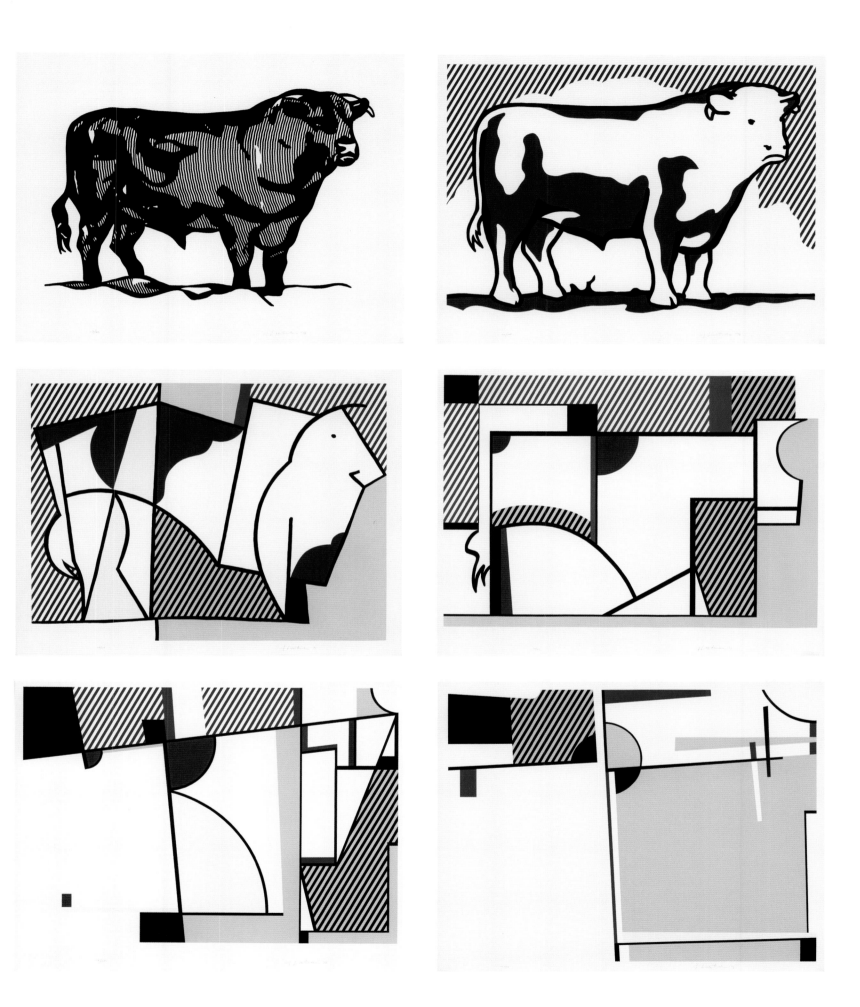

ED RUSCHA (American/estadounidense, b./n. 1937)

(left, from top to bottom/izquierda, de arriba hacia abajo)

News, Mews, Pews, Brews, Stews & Dues Series: News/Serie noticias,
maullidos, banquetas, brebajes, guisos y cuotas: noticias, edition/
edición 15/125, 1970
Screenprint with organic materials: black currant pie filling, red
salmon roe/Serigrafía con materiales orgánicos: relleno de tarta de
grosella negra, huevas de salmón rojo
23 × 31 in. (58.4 × 78.7 cm)

News, Mews, Pews, Brews, Stews & Dues Series: Pews/Serie noticias,
maullidos, banquetas, brebajes, guisos y cuotas: banquetas, edition/
edición 15/125, 1970
Screenprint with organic materials: Hershey's chocolate flavor
syrup, Camp coffee, chicory essence, squid ink/Serigrafía con
materiales orgánicos: jarabe de sabor a chocolate Hershey, café
Camp, esencia de achicoria, tinta de calamar
23 × 31 in. (58.4 × 78.7 cm)

News, Mews, Pews, Brews, Stews & Dues Series: Stews/Serie noticias,
maullidos, banquetas, brebajes, guisos y cuotas: guisos, edition/
edición 15/125, 1970
Screenprint with organic materials: crushed baked beans, caviar,
fresh strawberries, cherry pie filling, mango chutney, tomato paste,
crushed daffodils, crushed tulips, leaves/Serigrafía con materiales
orgánicos: frijoles cocidos triturados, caviar, fresas frescas, relleno
de tarta de cerezas, chutney de mango, pasta de tomate, narcisos
triturados, tulipanes triturados, hojas
23 × 31 in. (58.4 × 78.7 cm)

(right, from top to bottom/derecha de arriba hacia abajo)

News, Mews, Pews, Brews, Stews & Dues Series: Mews/Serie noticias,
maullidos, banquetas, brebajes, guisos y cuotas: maullidos, edition/
edición 15/125, 1970
Screenprint with organic materials: Bolognese sauce, black currant
pie filling, cherry pie filling, unmixed raw egg/Serigrafía con
materiales orgánicos: salsa boloñesa, relleno de tarta de
grosella negra, relleno de tarta de cereza, huevo crudo sin
mezclar
23 × 31 in. (58.4 × 78.7 cm)

News, Mews, Pews, Brews, Stews & Dues Series: Brews/Serie noticias,
maullidos, banquetas, brebajes, guisos y cuotas: brebajes, edition/
edición 15/125, 1970
Screenprint with organic materials: axle grease and caviar/Serigrafía
con materiales orgánicos: grasa de eje y caviar
23 × 31 in. (58.4 × 78.7 cm)

News, Mews, Pews, Brews, Stews & Dues Series: Dues/Serie noticias,
maullidos, banquetas, brebajes, guisos y cuotas: cuotas, edition/
edición 15/125, 1970
Screenprint with organic materials: Branston pickle/Serigrafía con
materiales orgánicos: aderezo Branston
23 × 31 in. (58.4 × 78.7 cm)

ANDY WARHOL (American/estadounidense, 1928–1987)
Hamburger (double)/Hamburguesa (doble), 1986
Screenprint/Serigrafía
31⅜ × 24 in. (79.7 × 61 cm)

HAMBURGER

WHOLESOME · DELICIOUS

The human capacity to be visually attracted to foods is universal. Evolutionary research suggests that we enjoy looking at food because the brain anticipates the physical satisfaction derived from eating. The shapes and colors of fruit likely drove early foraging decisions, and their aesthetics continue to play an important role in our choices about what to consume. The famous adage "we eat first with our eyes" is quickly evident in a trip to the grocery store, where produce is showcased with uniformity of shape, size, and color to appeal to the casual supermarket shopper.

While our varying opinions on food aesthetics are shaped by our cultural influences and life experiences, pieces of fruit in particular offer enormous potential for artists to tease a viewer's appetite. Through them an artist can explore form, shadow, texture, and color. In turn, they can arouse desire in the viewer by appealing to the senses of taste, touch, and smell.

Perhaps it is this inherent beauty and bodily desire for food that also makes it an apropos metaphor for sexual desire. With the associations of sin, fertility, and revelry wound up in fruits like apples, peaches, and grapes, depictions of fruits have the ability to stimulate more than one craving.

La capacidad humana de sentirse atraído visualmente por los alimentos es universal. Estudios sobre la evolución sugieren que disfrutamos mirar comida porque el cerebro anticipa la satisfacción física derivada del comer. Las formas y los colores de la fruta probablemente dictaron las primeras decisiones durante las búsquedas de alimentos, y su estética sigue desempeñando un papel importante en nuestras elecciones sobre qué consumir. El famoso dicho de que "primero comemos con los ojos" se hace evidente en una visita a la tienda, donde las frutas y verduras se exhiben con uniformidad de forma, tamaño y color para atraer al comprador casual de supermercado.

Aunque nuestras distintas opiniones sobre la estética de la comida están condicionadas por nuestras influencias culturales y experiencias en la vida, las frutas en particular ofrecen un enorme potencial para que les artistas despierten el apetito del espectador. A través de ellas, un artista puede explorar la forma, la sombra, la textura y el color. A su vez, pueden despertar el deseo del espectador apelando a los sentidos del gusto, del tacto y del olfato.

Tal vez sea esta belleza inherente y el deseo corporal por la comida lo que la convierte en una metáfora apropiada del deseo sexual. Por medio de las asociaciones con el pecado, la fertilidad y el jolgorio que contienen frutas como las manzanas, los melocotones y las uvas, las representaciones de las frutas tienen la capacidad de estimular más de un deseo.

EYE CANDY/
UN REGALO PARA LA VISTA

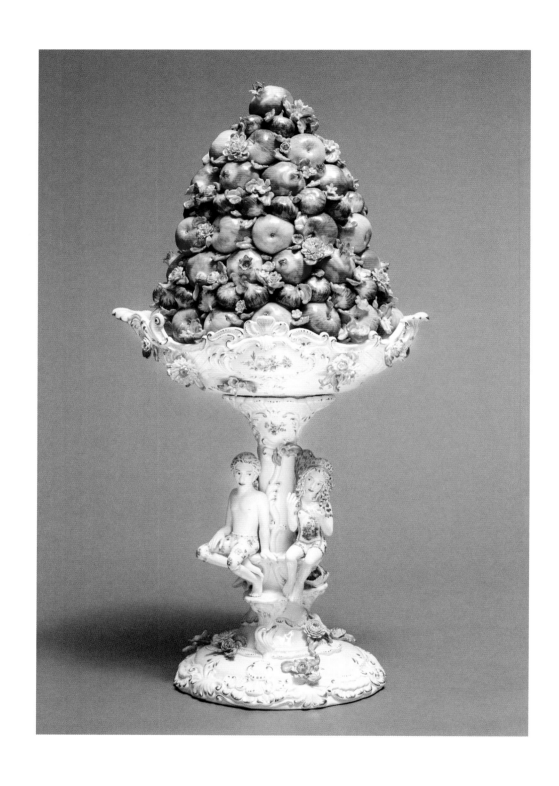

CHRIS ANTEMANN (American/estadounidense, b./n. 1970)
Fruit Pyramid/Pirámide de frutas, edition/edición 2/10, 2014
Meissen porcelain/Porcelana de Meissen
41¼ × 20⅞ × 14³/₁₆ in. (102.2 × 53 × 36 cm)

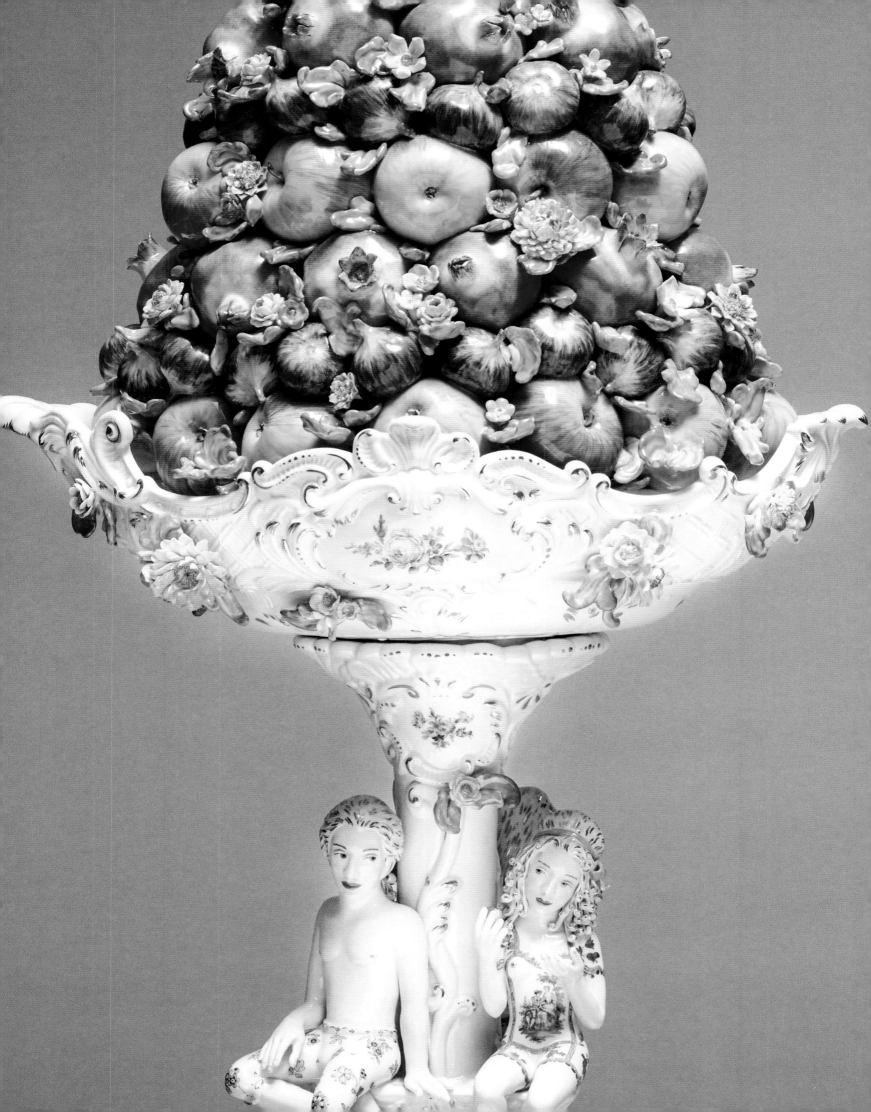

KATHERINE ACE (American/estadounidense, b./n. 1953)
Crop Circles 2/Círculos de las cosechas 2, 2008
Oil, alkyd, mixed media on canvas/Óleo, resina alquídica, técnica
mixta sobre lienzo
42 × 60 in. (106.7 × 152.4 cm)

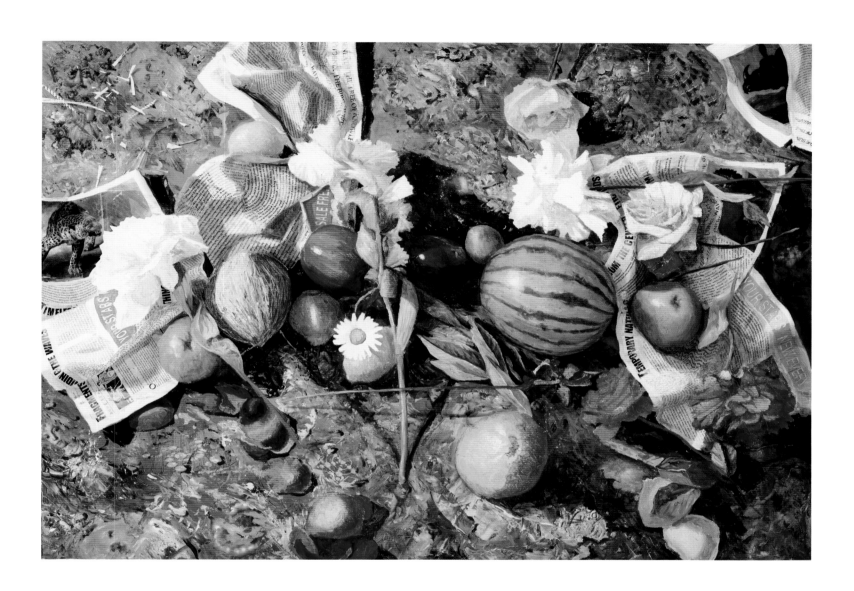

SHERRIE WOLF (American/estadounidense, b./n. 1952)

Artemisia Suite: Cherries after Artemisia/Suite Artemisia: Cerezas según Artemisia, edition/edición 24/40, 2002
Etching/Grabado
21¾ × 18¼ in. (55.3 × 46.4 cm)

Artemisia Suite: Bowl of Plums after Artemisia/Suite Artemisia: Tazón de ciruelas según Artemisia, edition/edición 24/40, 2002
Etching/Grabado
21¾ × 18¼ in. (55.3 × 46.4 cm)

Artemisia Suite: Three Pears after Artemisia/Suite Artemisia: Tres peras según Artemisia, edition/edición 24/40, 2002
Etching/Grabado
21¾ × 18¼ in. (55.3 × 46.4 cm)

Artemisia Suite: Two Pears after Artemisia/Suite Artemisia: Dos peras según Artemisia, edition/edición 24/40, 2002
Etching/Grabado
21¾ × 18¼ in. (55.3 × 46.4 cm)

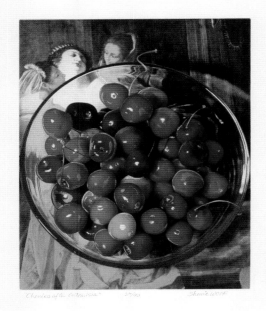

"Cherries of the Contessiria" 27/40 Sherrie Wolf

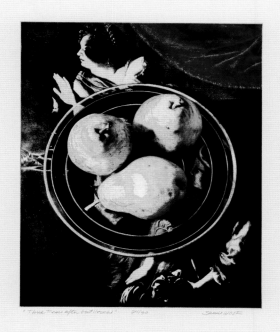

"Three Pears after Gaillraen" 29/40 Sherrie Wolf

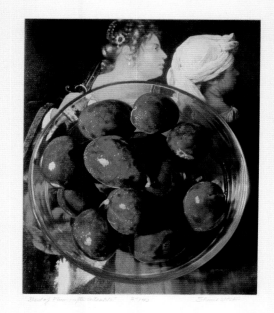

"Body of Plums after Leeliki" 21/40 Sherrie Wolf

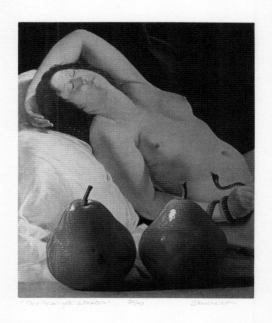

"Two Pears after la Toulouse" 34/40 Sherrie Wolf

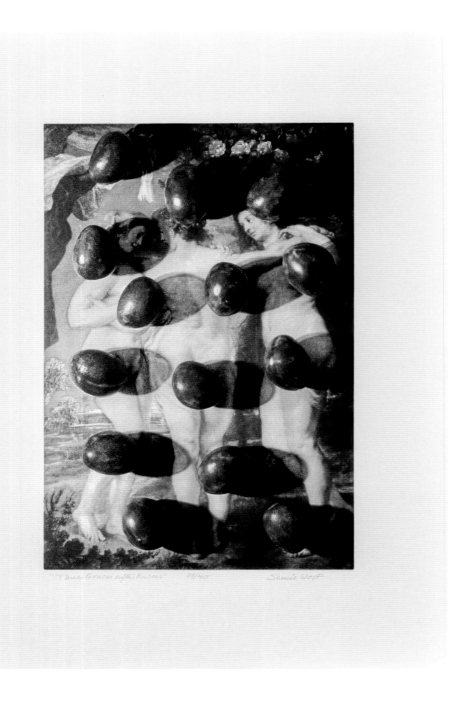

SHERRIE WOLF (American/estadounidense, b./n. 1952)

Artemisia Suite: Three Graces after Rubens/Suite Artemisia: Las Tres Gracias según Rubens, edition/edición 24/40, 2002
Etching/Grabado
24½ × 18¼ in. (62.2 × 46.4 cm)

(opposite page/página opuesta)

First Harvest/Primera cosecha, 2016
Oil on canvas/Óleo sobre lienzo
60 × 40 in. (152.4 × 101.6 cm)

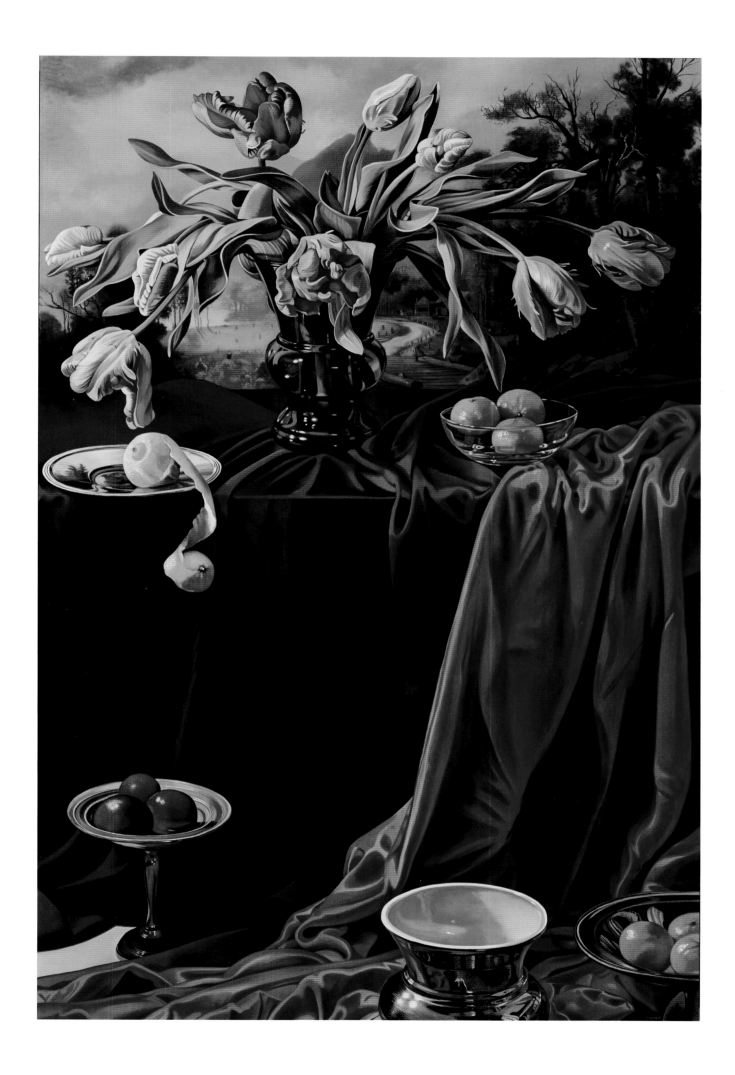

SHERRIE WOLF (American/estadounidense, b./n. 1952)

*Concert of Birds with Fruit and Pedestal/Concierto de pájaros con
fruta y pedestal,* 2008
Watercolor on paper/Acuarela sobre papel
29½ × 35 in. (74.9 × 88.9 cm)

Fruit with Rainbow/Fruta con arco iris, 2006
Oil on canvas/Óleo sobre lienzo
40¼ × 60¼ in. (102.2 × 153 cm)

The still lifes of Ellsworth Kelly and Donald Sultan walk a paradoxical line between naturalism and artifice. They are as minimal as they are complex; their subjects banal, yet simultaneously provocative. Although these works stem from botanical illustration and European still life traditions, Kelly and Sultan have moved these genres to a new level—one where a single object is elevated to a status worthy of its own monumental size and space.

Kelly uses crisp contours to delineate the forms of fruits, stems, and leaves. While pared down to the essence of line, his lithographs stimulate the senses, asking us to imagine the color, texture, and even the taste of the fruit. In contrast to Kelly's approach, Sultan builds up the fruits' forms through layers of hazy mist. They are textural and tangible, yet also seem artificial and unnatural.

The play of positive and negative space and of weighted mass versus contour line signal differing artistic approaches between the artists. Nevertheless, their works are connected by a deep examination of the aesthetics of fruit, inviting us to wonder at the sight of these familiar objects.

Las naturalezas muertas (o bodegones) de Ellsworth Kelly y Donald Sultan se encuentran en el límite paradójico entre naturalismo y artificio. Son tan mínimas como lo son complejas; sus temas son banales, pero a la vez provocadores. Aunque estas obras se derivan de la ilustración botánica y de las tradiciones de la naturaleza muerta europea, Kelly y Sultan han llevado esos géneros a un nuevo nivel—uno en el que un solo objeto es elevado a un estado digno de su propio tamaño y espacio monumentales.

Kelly utiliza contornos nítidos para delinear las formas de las frutas, los tallos y las hojas. Aunque se reducen a la esencia de la línea, sus litografías estimulan los sentidos, pidiéndonos que imaginemos el color, la textura e incluso el sabor de la fruta. En contraste con el método de Kelly, Sultan construye la forma de las frutas con capas de neblina difusa. Potencian la textura y son tangibles, pero también parecen artificiales y antinaturales.

El juego de espacio positivo y negativo y de masa ponderada versus líneas de contorno, señala los distintos enfoques artísticos entre les creadores. Sin embargo, sus obras están conectadas por un profundo estudio de la estética de la fruta, invitándonos a maravillarnos ante la visión de estos objetos familiares.

STILL LIFE/
NATURALEZA MUERTA

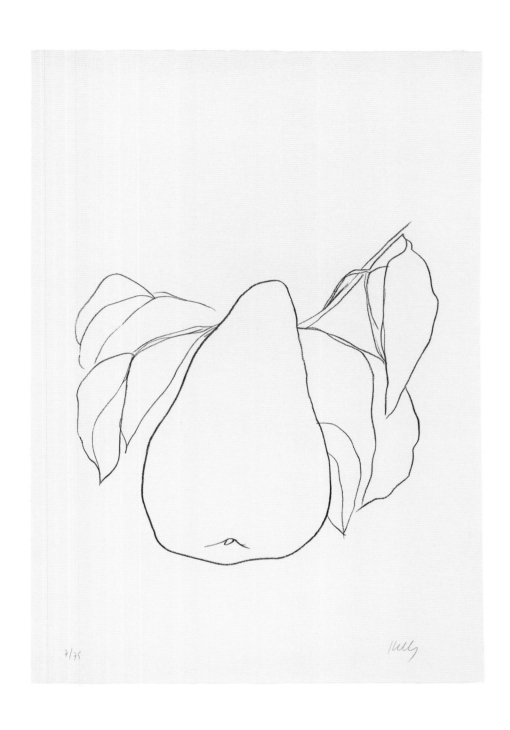

7/75

Kelly

ELLSWORTH KELLY (American/estadounidense, 1923–2015)

Suite of Plant Lithographs: Pear III (Poire III)/Conjunto de litografías sobre plantas: Pera III (Poire III), edition/edición 7/75, 1965–66
Lithograph/Litografía
34⅝ × 24¾ in. (88 × 62.9 cm)

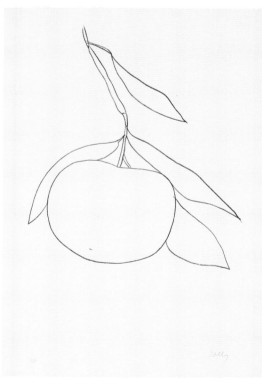

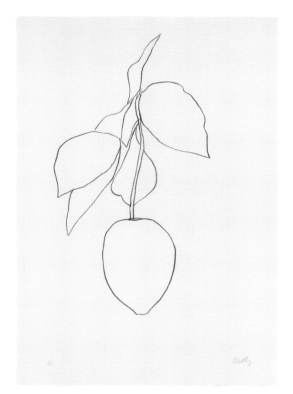

Suite of Plant Lithographs: Pear II (Poire II)/Suite de litografías de plantas: Pera II (Poire II), edition/edición 7/75, 1965–66
Lithograph/Litografía
34⅝ × 23⅜ in. (88 × 59.4 cm)

Suite of Plant Lithographs: Tangerine (Mandarine)/Conjunto de litografías de plantas: Mandarina (Mandarine), edition/edición 7/75, 1964–65
Lithograph/Litografía
35½ × 24⅛ in. (90.2 × 61.3 cm)

Suite of Plant Lithographs: Pear I (Poire I)/Conjunto de litografías de plantas: Pera I (Poire I), edition/edición 7/75, 1965–66
Lithograph/Litografía
35⅝ × 24½ in. (90.5 × 62.2 cm)

Suite of Plant Lithographs: Lemon (Citron)/Conjunto de litografías de plantas: Limón (Citron), edition/edición 7/75, 1964–65
Lithograph/Litografía
35⅜ × 24¼ in. (89.9 × 61.6 cm)

DONALD SULTAN (American/estadounidense, b./n. 1951)

Four Lemons: Yellow Lemon on Black, July 24, 2018/Cuatro limones: limón amarillo sobre negro, 24 de julio, 2018, edition/edición 15/40, 2018
Silkscreen with enamel ink and tar-like texture/Serigrafía con tinta de esmalte y textura de alquitrán
39 × 39 in. (99.1 × 99.1 cm)

Four Lemons: Black Lemon on Yellow, July 24, 2018/Cuatro limones: limón negro sobre amarillo, 24 de julio, 2018, edition/edición 15/40, 2018
Silkscreen with enamel ink and tar-like texture/Serigrafía con tinta de esmalte y textura de alquitrán
39 × 39 in. (99.1 × 99.1 cm)

Four Lemons: Black Lemon on White, July 24, 2018/Cuatro limones: limón negro sobre blanco, 24 de julio, 2018, edition/edición 15/40, 2018
Silkscreen with enamel ink and tar-like texture/Serigrafía con tinta de esmalte y textura de alquitrán
39 × 39 in. (99.1 × 99.1 cm)

Four Lemons: Black Lemon on Silver, July 24, 2018/Cuatro limones: limón negro sobre plata, 24 de julio, 2018, edition/edición 15/40, 2018
Silkscreen with enamel ink and tar-like texture/Serigrafía con tinta de esmalte y textura de alquitrán
39 × 39 in. (99.1 × 99.1 cm)

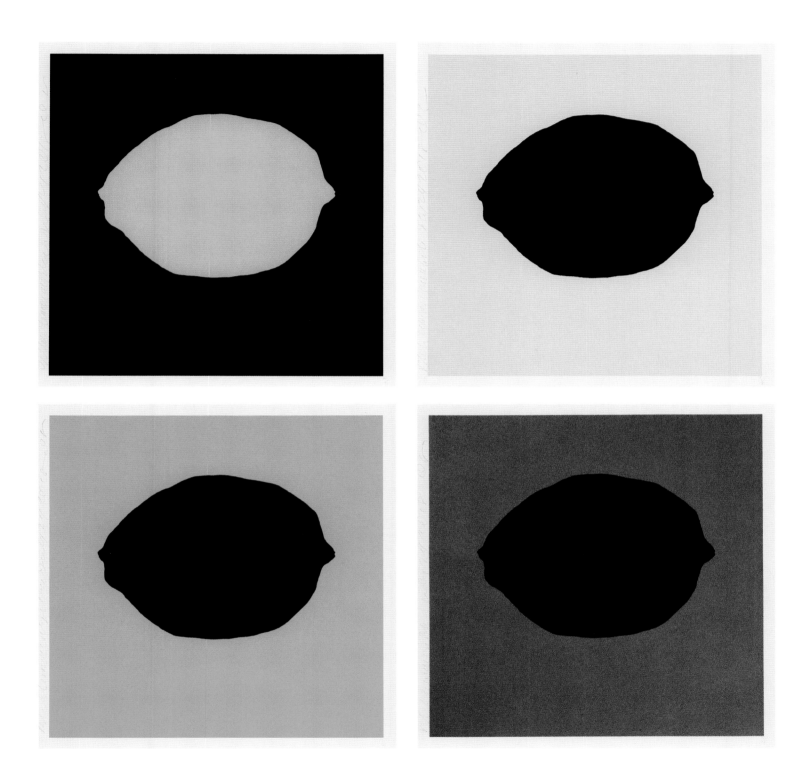

DONALD SULTAN (American/estadounidense, b./n. 1951)

Pomegranates/Granadas, edition/edición 13/60, 1990
Aquatint etching/Grabado al aguatinta
47 × 35⅝ in. (119.4 × 90.5 cm)

Pomegranates/Granadas, edition/edición 13/60, 1990
Aquatint etching/Grabado al aguatinta
47 × 35⅝ in. (119.4 × 90.5 cm)

Pomegranates/Granadas, edition/edición 13/60, 1990
Aquatint etching/Grabado al aguatinta
47 × 35⅝ in. (119.4 × 90.5 cm)

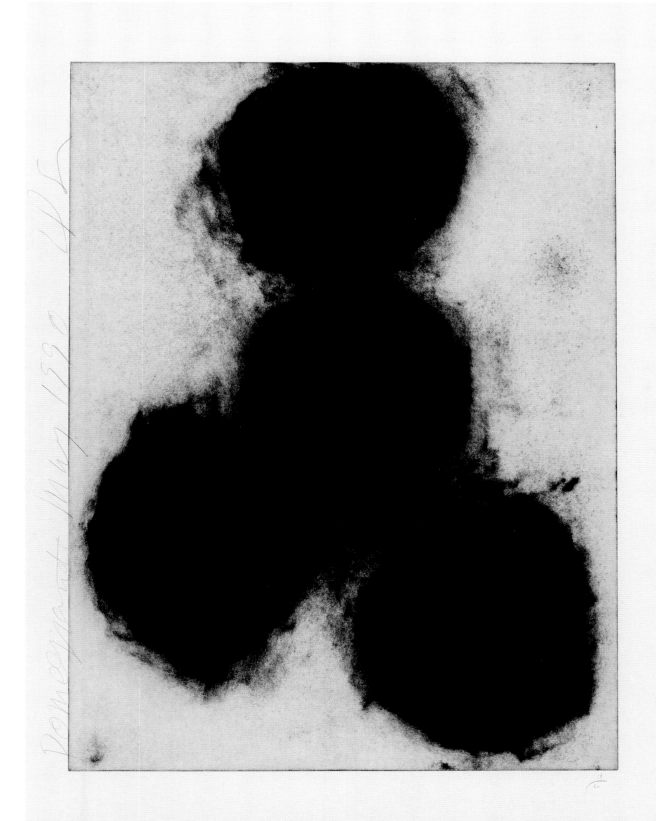

The world of food would be unimaginable without the accompaniment of drink, that grand array of liquids that flow from the absolutely essential to the purely pleasurable. And drinks recur with insistent regularity in works of art, once we begin to look for them. Their visual depiction poses a particular challenge: liquids, of course, have no inherent shape of their own. Accordingly, artists have resorted to a variety of approaches in order to portray drinks and drinking. The works in this section are loosely grouped according to those strategies.

In some cases, drinking vessels stand in for the fluids they contain—we see tumblers, stemware, bottles, cups, and cans, all with their own evocative contours. In other instances, artists have turned to corporate branding, relying on well-known logos to suggest the cultural ubiquity of the beverages they represent. Finally, there is the depiction of familiar settings—for example, the bar or the coffee shop—with which we associate specific kinds of liquid consumption.

Artists have often had to approach drinks obliquely, by way of the containers, signs, and rituals that surround them. Despite their visual evasiveness, it is clear that drinks are imbued with a host of significant and shifting meanings in our culture and in our lives.

El mundo de la comida sería inimaginable sin el acompañamiento de la bebida, esa gran variedad de líquidos que va desde lo absolutamente esencial a lo puramente placentero. Y las bebidas reaparecen con una regularidad persistente en las obras de arte, una vez que empezamos a buscarlas. Su representación visual plantea un desafío particular: los líquidos, por supuesto, no tienen una forma que les es inherente. Consecuentemente, les artistas han recurrido a una variedad de métodos para retratar bebidas y el beber. Las obras en esta sección están agrupadas de manera laxa de acuerdo a esas estrategias.

En algunos casos, los recipientes para beber remplazan a los líquidos que contienen: vemos vasos, copas, botellas, tazas y latas, todos con sus propios contornos evocadores. En otros casos, les artistas han recurrido a la marca corporativa, usando logotipos conocidos para sugerir la ubicuidad cultural de las bebidas que representan. Por último, está la representación de establecimientos familiares—por ejemplo, el bar o la cafetería—a los que asociamos con determinados tipos de consumo de líquidos.

Les artistas a menudo han tenido que abordar la representación de las bebidas de forma indirecta, a través de los recipientes, los signos y los rituales que las rodean. A pesar de su evasión visual, está claro que las bebidas están empapadas de una serie de significados relevantes y cambiantes en nuestra cultura y en nuestras vidas.

ELIXIRS AND LIBATIONS/
ELIXIRES Y LIBACIONES

JOSEPH BEUYS (German/alemán, 1912–1986)
Wirtschaftswert Thüringer Kräuertee (Economic Value Thüringer Herbal Tea/Valor económico del té de hierbas de Turingia), 1977–84
Herbal tea packet with felt-tip pen and stamp/Paquete de infusiones con rotulador y sello
8¼ × 4¼ in. (21 × 10.8 cm)

ROBERT COTTINGHAM (American/estadounidense, b./n. 1935)
American Signs: Champagne/Señales norteamericanas: champagne, edition/edición 67/100, 2009
Screenprint/Serigrafía
40⅛ × 39⅛ in. (101.9 × 99.4 cm)

(following pages/siguientes páginas)
DAVID HOCKNEY (British/británico, b./n. 1937)
Caribbean Tea Time/La hora del té caribeña, edition/edición 29/36, 1987
Lithograph, screenprint, collage, stencil, folding screen/Litografía, serigrafía, collage, plantilla, biombo
84½ x 125 x 20 in. (open, concertina-style/abierta, estilo concertina) (214.6 x 317.5 x 50.8 cm)

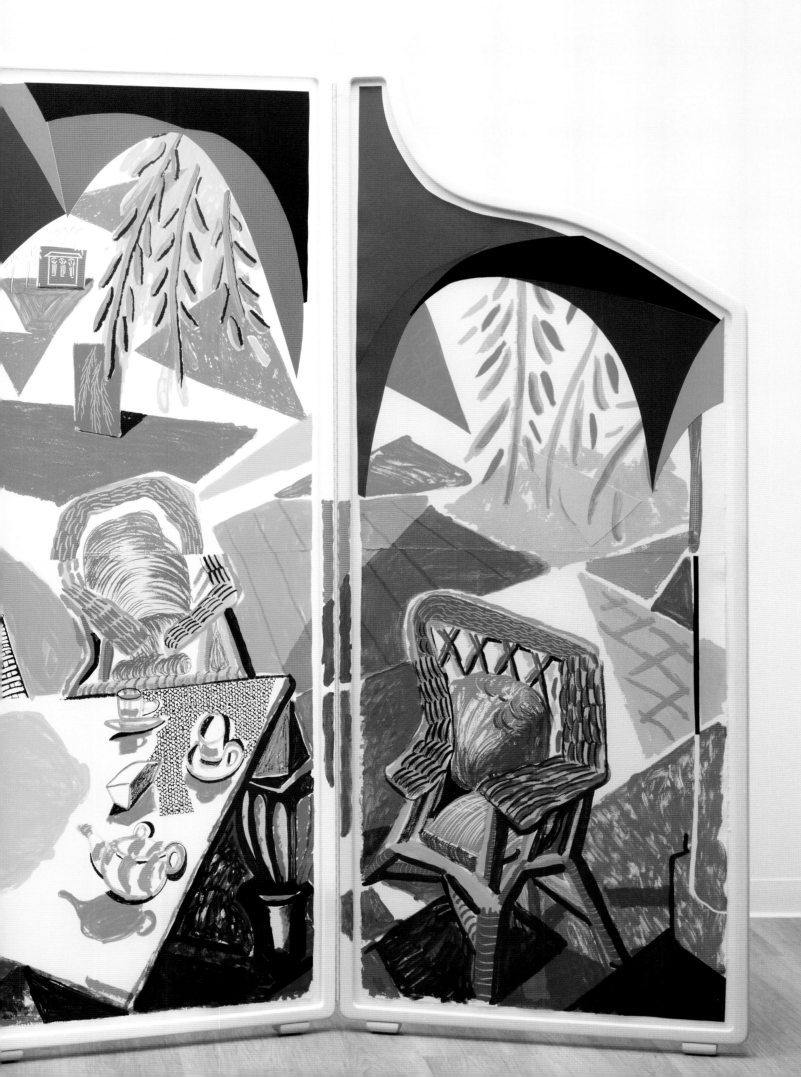

JASPER JOHNS (American/estadounidense, b./n. 1930)

1st Etchings: Ale Cans/Primeros grabados: Latas de cerveza,
edition/edición 13/26, 1968
Etching and photoengraving/Grabado y fotograbado
25⅞ × 20 in. (65.7 × 50.8 cm)

*1st Etchings: Ale Cans, title page/Primeros grabados: Latas de
cerveza, portada*, edition/edición 23/26, 1968
Etching/Grabado
28 × 20½ in. (71.1 × 52.1 cm)

CAFFEINE DREAMS

BRUCE NAUMAN (American/estadounidense, b./n. 1941)
Caffeine Dreams/Sueños de cafeína, edition/edición 24/75, 1987
Offset lithograph/Litografía offset
29⅝ × 24⅛ in. (75.3 × 61.3 cm)

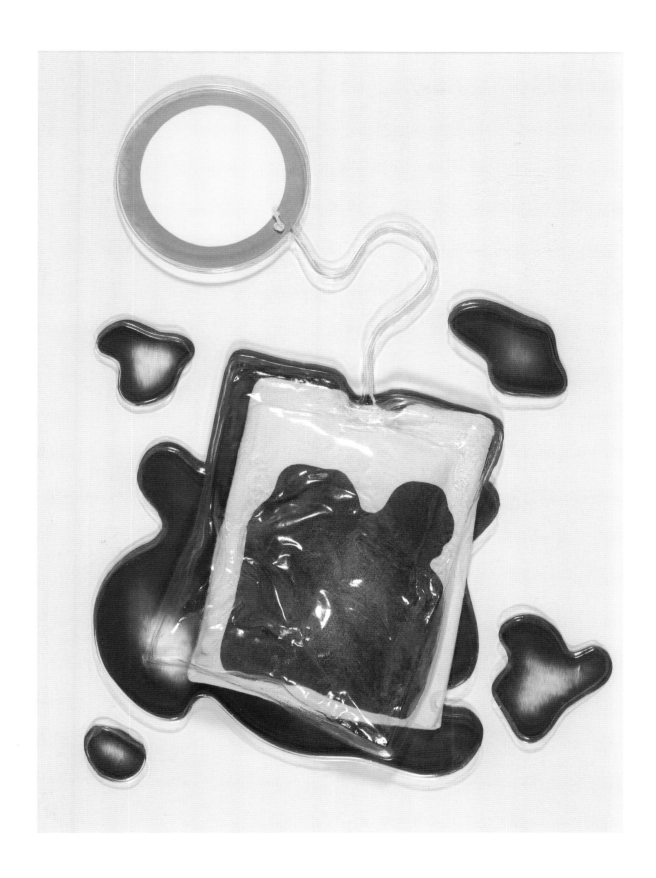

CLAES OLDENBURG (American, b. Sweden/estadounidense, n. Suecia, 1929)
Tea Bag/Bolsa de té, edition/edición 85/125, 1966
Screenprint with felt and cord on vinyl, and vacuum-formed vinyl/
Serigrafía con fieltro y cordón sobre vinilo, y vinilo moldeado
al vacío
38⅜ × 27⅛ in. (97.5 × 68.9 cm)

ROBERT RAUSCHENBERG (American/estadounidense, 1925–2008)
L.A. Uncovered Series: L.A. Uncovered #3/Serie L.A. descubierto: L.A. descubierto #3, edition/edición RTP, 1998
Screenprint/Serigrafía
24½ × 20¾ in. (62.2 × 52.7 cm)

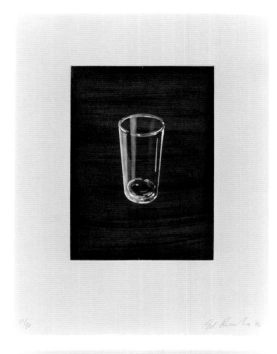 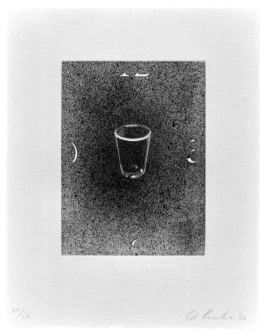 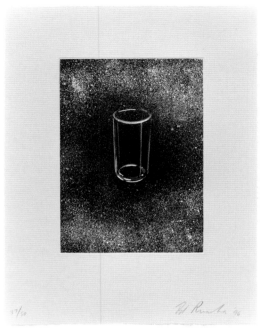

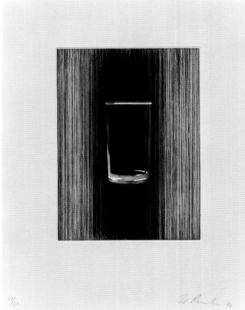 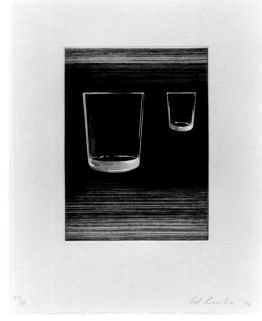 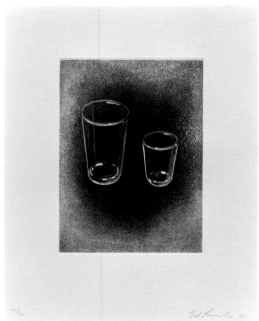

ED RUSCHA (American/estadounidense, b./n. 1937)

(top row, from left to right/fila de arriba, de izquierda a derecha)

Sunliner: Sunliner #1, edition/edición 37/50, 1995
Aquatint and etching/Aguatinta y grabado
17 × 13 in. (43.2 × 33 cm)

Sunliner: Sunliner #2, edition/edición 37/50, 1995
Aquatint and etching/Aguatinta y grabado
17 × 13 in. (43.2 × 33 cm)

Sunliner: Sunliner #3, edition/edición 37/50, 1995
Aquatint and etching/Aguatinta y grabado
17 × 13 in. (43.2 × 33 cm)

(bottom row, from left to right/fila de abajo, de izquierda a derecha)

Sunliner: Sunliner #4, edition/edición 37/50, 1995
Aquatint and etching/Aguatinta y grabado
17 × 13 in. (43.2 × 33 cm)

Sunliner: Sunliner #5, edition/edición 37/50, 1995
Aquatint and etching/Aguatinta y grabado
17 × 13 in. (43.2 × 33 cm)

Sunliner: Sunliner #6, edition/edición 37/50, 1995
Aquatint and etching/Aguatinta y grabado
17 × 13 in. (43.2 × 33 cm)

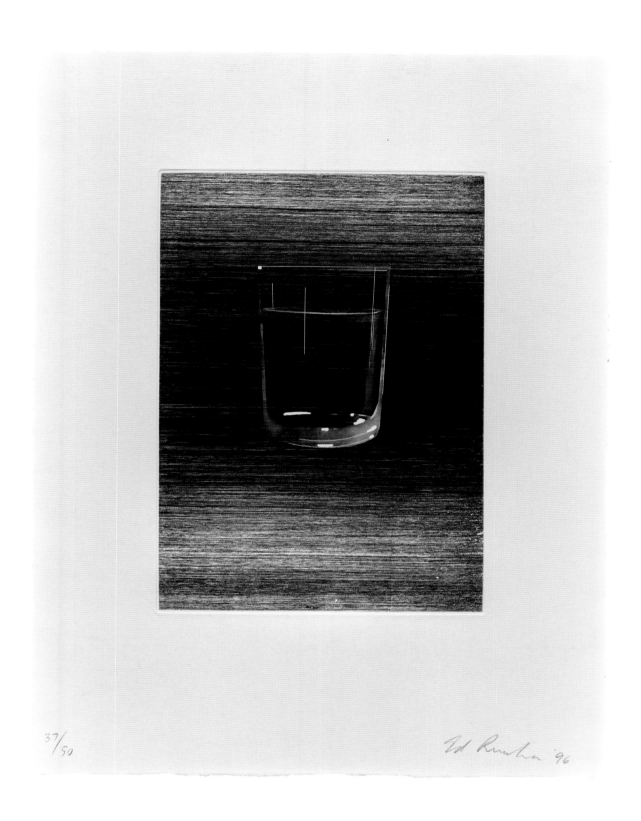

37/50

Ed Ruscha '96

Sunliner: Sunliner #7, edition/edición 37/50, 1995
Aquatint and etching/Aguatinta y grabado
17 × 13 in. (43.2 × 33 cm)

JONATHAN SELIGER (American/estadounidense, b./n. 1955)
Pint I/Pinta I, edition/edición 1/15, 2000
Lithograph/Litografía
38⅞ × 11⅝ in. (98.7 × 29.5 cm)

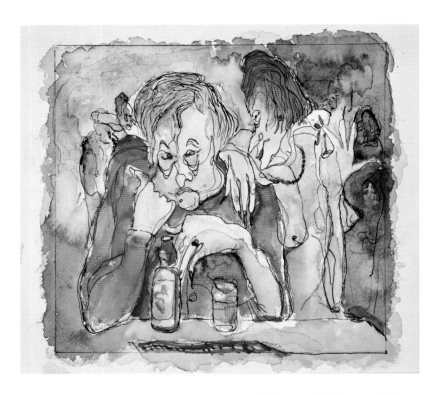

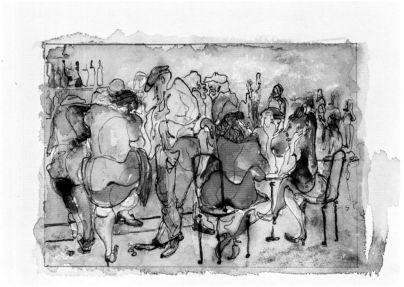

ANDY WARHOL (American/estadounidense, 1928–1987)

Untitled (Man and a Woman in a Bar)/Sin título (Hombre y una mujer en un bar), 1947
Watercolor, ink, and graphite on paper/Acuarela, tinta y grafito sobre papel
8⅝ × 9⅝ in. (22 × 24.5 cm)

Untitled (Bar Scene)/Sin título (Escena de bar), 1947
Watercolor and ink on paper/Acuarela y tinta sobre papel
7⅛ × 9⅝ in. (18.1 × 24.5 cm)

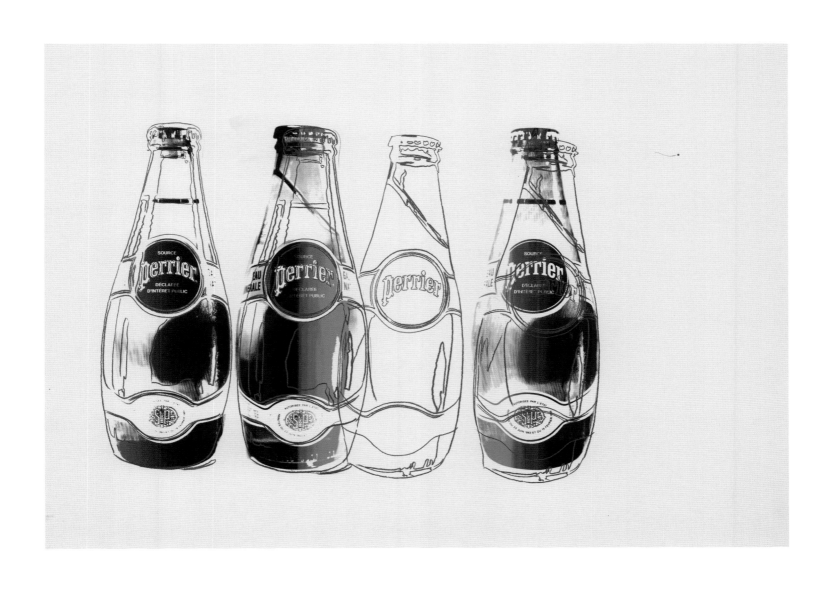

Perrier, 1983
Screenprint/Serigrafía
24⅝ × 34⅛ in. (62.5 × 86.7 cm)

CHECKLIST OF THE EXHIBITION/
LISTA DE OBRAS DE LA EXPOSICIÓN

KATHERINE ACE (American/estadounidense, b./n. 1953)
All works © Courtesy the artist and Froelick Gallery

Crop Circles 2/Círculos de las cosechas 2, 2008
Oil, alkyd, mixed media on canvas/Óleo, resina alquídica, técnica mixta sobre lienzo
42 × 60 in. (106.7 × 152.4 cm)

Cupid & Psyche with Cut Apple/Cupido y Psique con manzana cortada, ca. 2010
Oil on canvas/Óleo sobre lienzo
30 × 40 in. (76.2 × 101.6 cm)

NEAL AMBROSE-SMITH (Native American, Salish-Kootenai, Métis-Cree, Sho-Ban/nativo norteamericano, Salish-Kootenai, Métis-Cree, Sho-Ban, b./n. 1966)
The World According to Monsanto/El mundo según Monsanto, edition/edición 29/92, 2014
Relief print/Grabado en relieve
10 × 8 in. (25.4 × 20.3 cm)
© Neal Ambrose-Smith

CHRIS ANTEMANN (American/estadounidense, b./n. 1970)
All works © Chris Antemann in Collaboration with MEISSEN

Covet/Deseo, edition/edición 3/8, 2013
Meissen porcelain/Porcelana de Meissen
13¼ × 19 × 8 in. (33.7 × 48.3 × 20.3 cm)

Fruit Pyramid/Pirámide de frutas, edition/edición 2/10, 2014
Meissen porcelain/Porcelana de Meissen
41¼ × 20⅞ × 14³⁄₁₆ in. (102.2 × 53 × 36 cm)

JOHN BALDESSARI (American/estadounidense, 1931–2020)
All works © John Baldessari 2018. Courtesy Estate of John Baldessari © 2021

AND ONE SARDINE/Y UNA SARDINA, edition/edición 35/50, 2018
Screenprint/Serigrafía
35½ × 28 in. (90.2 × 71.1 cm)

BEST MEN/PADRINOS, edition/edición 35/50, 2018
Screenprint/Serigrafía
33 × 28 in. (83.8 × 71.1 cm)

I HAVE AN ELEPHANT/TENGO UN ELEFANTE, edition/edición 35/50, 2018
Screenprint/Serigrafía
33 × 28 in. (83.8 × 71.1 cm)

TRUFFLE BUTTER/MANTEQUILLA CON TRUFA, edition/edición 35/50, 2018
Screenprint/Serigrafía
32½ × 28 in. (82.6 × 71.1 cm)

WHISKEY IN THE JAR/WHISKY EN LA JARRA, edition/edición 35/50, 2018
Screenprint/Serigrafía
33 × 28 in. (83.8 × 71.1 cm)

YOGURT/YOGURT, edition/edición 35/50, 2018
Screenprint/Serigrafía
33¼ × 28 in. (81.9 × 71.1 cm)

JOSEPH BEUYS (German/alemán, 1912–1986)
All works © 2021 Artists Rights Society (ARS), New York / VG Bild-Kunst, Bonn

Food for Thought/Alimento para el pensamiento, 1977
Lithograph/Litografía
34⅝ × 6½ in. (88 × 16.5 cm)

Wirtschaftswert Thüringer Kräuertee (Economic Value Thüringer Herbal Tea/Valor económico del té de hierbas de Turingia), 1977–84
Herbal tea packet with felt tip pen and stamp/Paquete de infusiones con rotulador y sello
8¼ × 4¼ in. (21 × 10.8 cm)

Capri Battery/Batería Capri, edition/edición AP 49/50, 1985
Light bulb (Mazda), plug socket, and exchangeable lemon/Bombilla (Mazda), enchufe y limón intercambiable
6 × 4½ × 4 in. (15.2 × 11.4 × 10.2 cm)

EMILY BROCK (American/estadounidense, b./n. 1945)
Diner Story/Relato en la cafetería, 2011
Kiln-worked, cast, and lampworked glass/Vidrio trabajado en horno, fundido y con soplete
17 × 15 × 13 in. (43.2 × 38.1 × 33 cm)
© Emily Brock

ENRIQUE CHAGOYA (American, b. Mexico/estadounidense, n. Mexico, 1953)
The Enlightened Savage/El salvaje ilustrado, edition/edición 14/40, 2002
Digital pigment prints on paper wrapped around cans with silkscreened cardboard box/Impresiones digitales de pigmentos sobre papel envuelto en unas latas con caja de cartón serigrafiada
(a–j): 16 × 14 × 5 in. (40.6 × 35.6 × 12.7 cm), box (k): 5 × 16 × 7 in. (12.7 × 40.6 × 17.8 cm)
© Enrique Chagoya

CORWIN "CORKY" CLAIRMONT (Native American, Salish-Kootenai/nativo norteamericano, Salish-Kootenai, b./n. 1946)
Tarsand Trout/Trucha de Tar Sands, edition/edición 29/92, 2014
Relief print/Grabado en relieve
8 × 10 in. (20.3 × 25.4 cm)
© Corwin Clairmont

WARRINGTON COLESCOTT (American/estadounidense, 1921–2018)
Fish Eaters/Comedores de pescados, 1986
Watercolor/Acuarela
21¾ × 30½ in. (55.3 × 77.5 cm)
© Estate of Warrington Colescott

ROBERT COTTINGHAM (American/estadounidense, b./n. 1935)
American Signs: Champagne/Señales norteamericanas: champagne, edition/edición 67/100, 2009
Screenprint/Serigrafía
40⅛ × 39⅛ in. (101.9 × 99.4 cm)
© Robert Cottingham

ABRAHAM CRUZVILLEGAS (Mexican/mexicano, b./n. 1968)
Ichárhuta, edition/edición 43/49, 2017
Mixografia print on handmade paper and archival pigment print/Impresión Mixografía sobre papel hecho a mano, e impresión de archivo pigmentada
12¾ × 7½ in. (32.4 × 19.1 cm)
©Abraham Cruzvillegas. Courtesy of Mixografia

RICHARD ESTES (American/estadounidense, b./n. 1936)
All works © Richard Estes, Courtesy Menconi + Schoelkopf

Urban Landscapes I: Oriental Cuisine/Paisajes urbanos I: Cocina oriental, edition/edición 29/75, 1972
Screenprint/Serigrafía
19⅝ × 27½ in. (49.9 × 69.9 cm)

Urban Landscapes II: Supermarket, San Francisco/Paisajes urbanos II: Supermercado, San Francisco, edition/edición 57/100, 1979
Screenprint/Serigrafía
27½ × 19½ in. (69.9 × 49.5 cm)

DAVID GILHOOLY (American/estadounidense, 1943–2013)
Lite/Late Lunch/Almuerzo ligero/tardío, 1983
Painted and glazed ceramic and wood/Cerámica pintada y esmaltada y madera
13 × 20 × 15½ in. (33 × 50.8 × 39.4 cm)

ROBERT GOBER (American/estadounidense, b./n. 1954)
Untitled/Sin título, edition/edición 63/75, 1993–94
Photolithograph/Fotolitografía
12¼ × 12 in. (31.1 × 30.5 cm)
© Robert Gober, Courtesy Matthew Marks Gallery

RED GROOMS (American/estadounidense, b./n. 1937)
All works © Red Grooms, Member of Artists Rights Society (ARS)

Deli/Lonchería, edition/edición 38/50, 2004
Three-dimensional lithograph/Litografía tridimensional
26½ × 26⅜ × 7⅝ in. (67.3 × 67 × 19.4 cm)

No Gas Café/Café No Gas, edition/edición 39/75, 1971
Lithograph/Litografía
28 × 21¾ in. (71.1 × 55.3 cm)

DAMIEN HIRST (British/británico, b./n. 1965)
All works © Damien Hirst and Science Ltd. All rights reserved / DACS, London / ARS, NY 2021

The Last Supper: Beans, Chips/La última cena: frijoles, papas fritas, edition of 150/edición de 150, 1999
Screenprint/Serigrafía
60 × 40 in. (152.4 × 101.6 cm)

The Last Supper: Chicken/La última cena: pollo, edition of 150/edición de 150, 1999
Screenprint/Serigrafía
60 × 40 in. (152.4 × 101.6 cm)

The Last Supper: Corned Beef/La última cena: carne en conserva, edition of 150/edición de 150, 1999
Screenprint/Serigrafía
60 × 40 in. (152.4 × 101.6 cm)

The Last Supper: Cornish Pasty, Peas/La última cena: pastel de Cornualles, chícharos, edition of 150/edición de 150, 1999
Screenprint/Serigrafía
60 × 40 in. (152.4 × 101.6 cm)

The Last Supper: Dumpling/La última cena: dumpling, edition of 150/edición de 150, 1999
Screenprint/Serigrafía
40 × 60 in. (101.6 × 152.4 cm)

The Last Supper: Meatballs/La última cena: albóndigas, edition of 150/edición de 150, 1999
Screenprint/Serigrafía
60 × 40 in. (152.4 × 101.6 cm)

The Last Supper: Mushroom Pie/La última cena: pastel de champiñones, edition of 150/edición de 150, 1999
Screenprint/Serigrafía
60 × 40 in. (152.4 × 101.6 cm)

The Last Supper: Omelette/La última cena: omelette, edition of 150/edición de 150, 1999
Screenprint/Serigrafía
60 × 40 in. (152.4 × 101.6 cm)

The Last Supper: Salad/La última cena: ensalada, edition of 150/edición de 150, 1999
Screenprint/Serigrafía
60 × 40 in. (152.4 × 101.6 cm)

The Last Supper: Sandwich/La última cena: sándwich, edition of 150/edición de 150, 1999
Screenprint/Serigrafía
60 × 40 in. (152.4 × 101.6 cm)

The Last Supper: Sausages/La última cena: salchichas, edition of 150/edición de 150, 1999
Screenprint/Serigrafía
60 × 40 in. (152.4 × 101.6 cm)

DAVID HOCKNEY (British/británico, b./n. 1937)
Caribbean Tea Time/La hora del té caribeña, edition/edición 29/36, 1987
Lithograph, screenprint, collage, stencil, folding screen/Litografía, serigrafía, collage, plantilla, biombo
84½ × 125 × 20 in. (open, concertina-style/abierta, estilo concertina) (214.6 × 317.5 × 50.8 cm)
© David Hockney / Tyler Graphics Ltd

JENNY HOLZER (American/estadounidense, b./n. 1950)
Survival Series: If You're Considered Useless No One Will Feed You Anymore/Serie de supervivencia: si te consideran inútil nadie te alimentará más, edition/edición 3/10, 1983–84
Cast aluminum plaque with black paint/Placa de aluminio fundido con pintura negra
3 × 10 × ⅛ in. (7.6 × 25.4 × .32 cm)
© 2021 Jenny Holzer, member Artists Rights Society (ARS), New York

MALIA JENSEN (American/estadounidense, b./n. 1966)
All works © Courtesy of the artist and Elizabeth Leach Gallery

Butterscape/Escapemantequilla, edition/edición 1/3, 2008
Plaster of Paris and enamel/Yeso de Paris y esmalte
1¾ × 8 × 8 in. (4.5 × 20.3 × 20.3 cm)

Untitled 4 (salt lick)/Sin título 4 (bloque de sal para lamer), 2010
Carved salt lick/Bloque de sal para lamer tallado
9 × 9 × 11 in. (22.9 × 22.9 × 27.9 cm)

JASPER JOHNS (American/estadounidense, b./n. 1930)
1st Etchings: Ale Cans/Primeros grabados: Latas de cerveza, edition/edición 13/26, 1968
Etching and photoengraving/Grabado y fotograbado
25⅞ × 20 in. (65.7 × 50.8 cm)
© 2021 Jasper Johns and ULAE / Licensed by VAGA at Artists Rights Society (ARS), NY, Published by Universal Limited Art Editions

1st Etchings: Ale Cans, title page/Primeros grabados: Latas de cerveza, edition/edición 23/26, 1968
Etching/Grabado
28 × 20½ in. (71.1 × 52.1 cm)
© 2021 Jasper Johns and ULAE / Licensed by VAGA at Artists Rights Society (ARS), NY, Published by Universal Limited Art Editions

Untitled (Coca-Cola and Grid)/Sin título (Coca-Cola y cuadrícula), edition/edición 53/66, 1971
Lithograph/Litografía
39 × 29½ in. (99.1 × 74.9 cm)
© 2021 Jasper Johns and Gemini G.E.L. / Licensed by VAGA at Artists Rights Society (ARS), NY, Published by Gemini G.E.L

ALEX KATZ (American/estadounidense, b./n. 1927)
Cow (small)/Vaca (pequeña), edition/edición 48/99, 2004
Screenprint on aluminum/Serigrafía sobre aluminio
16 × 40¾ × 3¾ in. (40.6 × 103.5 × 9.5 cm)
© 2021 Alex Katz / Licensed by VAGA at Artists Rights Society (ARS), NY

ELLSWORTH KELLY (American/estadounidense, 1923–2015)
All works © Ellsworth Kelly Foundation, Courtesy Matthew Marks Gallery

Suite of Plant Lithographs: Grapefruit (Pamplemousse)/Conjunto de litografías de plantas: Toronja (Pamplemousse), edition/edición 7/75, 1964–65
Lithograph/Litografía
35⅜ × 24¼ in. (89.9 × 61.6 cm)

Suite of Plant Lithographs: Lemon (Citron)/Conjunto de litografías de plantas: Limón (Citron), edition/edición 7/75, 1964–65
Lithograph/Litografía
35⅜ × 24¼ in. (89.9 × 61.6 cm)

Suite of Plant Lithographs: Tangerine (Mandarine)/Conjunto de litografías de plantas: Mandarina (Mandarine), edition/edición 7/75, 1964–65
Lithograph/Litografía
35½ × 24⅛ in. (90.2 × 61.3 cm)

Suite of Plant Lithographs: Pear I (Poire I)/Conjunto de litografías de plantas: Pera I (Poire I), edition/edición 7/75, 1965–66
Lithograph/Litografía
35⅝ × 24½ in. (90.5 × 62.2 cm)

Suite of Plant Lithographs: Pear II (Poire II)/Suite de litografías de plantas: Pera II (Poire II), edition/edición 7/75, 1965–66
Lithograph/Litografía
34⅝ × 23⅜ in. (88 × 59.4 cm)

Suite of Plant Lithographs: Pear III (Poire III)/Conjunto de litografías sobre plantas: Pera III (Poire III), edition/edición 7/75, 1965–66
Lithograph/Litografía
34⅝ × 24¾ in. (88 × 62.9 cm)

ROY LICHTENSTEIN (American/estadounidense, 1923–1997)
All works © Estate of Roy Lichtenstein

Bull Profile Series, Bull I/Serie de perfiles de toro, Toro I, edition/edición 14/100, 1973
Screenprint, lithograph, linocut/Serigrafía, litografía, linograbado
27 × 35 in. (68.6 × 88.9 cm)

Bull Profile Series, Bull II/Serie de perfiles de toro, Toro II, edition/edición 14/100, 1973
Screenprint, lithograph, linocut/Serigrafía, litografía, linograbado
27 × 35 in. (68.6 × 88.9 cm)

Bull Profile Series, Bull III/Serie de perfiles de toro, Toro III, edition/edición 14/100, 1973
Screenprint, lithograph, linocut/Serigrafía, litografía, linograbado
27 × 35¹/₁₆ in. (68.6 × 89.1 cm)

Bull Profile Series, Bull IV/Serie de perfiles de toro, Toro IV, edition/edición 14/100, 1973
Screenprint, lithograph, linocut/Serigrafía, litografía, linograbado
27 × 35 in. (68.6 × 88.9 cm)

Bull Profile Series, Bull V/Serie de perfiles de toro, Toro V, edition/edición 14/100, 1973
Screenprint, lithograph, linocut/Serigrafía, litografía, linograbado
27¹/₁₆ × 35¹/₁₆ in. (68.7 × 89.1 cm)

Bull Profile Series, Bull VI/Serie de perfiles de toro, Toro VI, edition/edición 14/100, 1973
Screenprint, lithograph, linocut/Serigrafía, litografía, linograbado
27 × 35 in. (68.6 × 88.9 cm)

Turkey Shopping Bag/Bolsa de la compra con pavo, from an edition of approx. 125/de una edición de 125 aprox., 1964
Screenprint on wove paper bag/Serigrafía sobre bolsa de papel uniforme
19�5/16 × 17¹/16 in. (49.1 × 43.3 cm)

HUNG LIU (American, b. China/estadounidense, n. China, 1948–2021)
Women Working: Millstone/Mujeres trabajando: Muela, edition/edición 29/35, 1999
Color softground and spitbite aquatint etching with scrape and burnish/Aguafuerte en color y grabado al aguatinta con raspado y bruñido
40¾ × 54½ in. (103.5 × 138.4 cm)
© Hung Liu & Jeff Kelley

BRUCE NAUMAN (American/estadounidense, b./n. 1941)
Caffeine Dreams/Sueños de cafeína, edition/edición 24/75, 1987
Offset lithograph/Litografía offset
29⅝ × 24⅛ in. (75.3 × 61.3 cm)
© 2021 Bruce Nauman / Artists Rights Society (ARS), New York

CLAES OLDENBURG (American, b. Sweden/estadounidense, n. Suecia, 1929)
All works © Claes Oldenburg

Tea Bag/Bolsa de té, edition/edición 85/125, 1966
Screenprint with felt and cord on vinyl, and vacuum-formed vinyl/Serigrafía con fieltro y cordón sobre vinilo, y vinilo moldeado al vacío
38⅜ × 27⅛ in. (97.5 × 68.9 cm)

Wedding Souvenir/Recuerdo de boda, exhibition proof of an edition of approx. 200/edición de 200 aprox., 1966
Plaster and white paint/Yeso y pintura blanca
5½ × 6½ × 2¼ in. (14 × 16.5 × 5.7 cm)

ROBERT RAUSCHENBERG (American/estadounidense, 1925–2008)
L.A. Uncovered Series: L.A. Uncovered #3/Serie L.A. descubierto: L.A. descubierto #3, edition/edición RTP, 1998
Screenprint/Serigrafía
24½ × 20¾ in. (62.2 × 52.7 cm)
© 2021 Robert Rauschenberg Foundation and Gemini G.E.L., LLC/Licensed by VAGA at Artists Rights Society (ARS), NY, Published by Gemini G.E.L., LLC

ED RUSCHA (American/estadounidense, b./n. 1937)
All works © Ed Ruscha

News, Mews, Pews, Brews, Stews & Dues Series: Brews/Serie noticias, maullidos, banquetas, brebajes, guisos y cuotas: brebajes, edition/edición 15/125, 1970
Screenprint with organic materials: axle grease and caviar/Serigrafía con materiales orgánicos: grasa de eje y caviar
23 × 31 in. (58.4 × 78.7 cm)

News, Mews, Pews, Brews, Stews & Dues Series: Dues/Serie noticias, maullidos, banquetas, brebajes, guisos y cuotas: cuotas, edition/edición 15/125, 1970
Screenprint with organic materials: Branston pickle/Serigrafía con materiales orgánicos: aderezo Branston
23 × 31 in. (58.4 × 78.7 cm)

News, Mews, Pews, Brews, Stews & Dues Series: Mews/Serie noticias, maullidos, banquetas, brebajes, guisos y cuotas: maullidos, edition/edición 15/125, 1970
Screenprint with organic materials: Bolognese sauce, black currant pie filling, cherry pie filling, unmixed raw egg/Serigrafía con materiales orgánicos: salsa boloñesa, relleno de tarta de grosella negra, relleno de tarta de cereza, huevo crudo sin mezclar
23 × 31 in. (58.4 × 78.7 cm)

News, Mews, Pews, Brews, Stews & Dues Series: News/Serie noticias, maullidos, banquetas, brebajes, guisos y cuotas: noticias, edition/edición 15/125, 1970
Screenprint with organic materials: black currant pie filling, red salmon roe/Serigrafía con materiales orgánicos: relleno de tarta de grosella negra, huevas de salmón rojo
23 × 31 in. (58.4 × 78.7 cm)

News, Mews, Pews, Brews, Stews & Dues Series: Pews/Serie noticias, maullidos, banquetas, brebajes, guisos y cuotas: banquetas, edition/edición 15/125, 1970
Screenprint with organic materials: Hershey's chocolate flavor syrup, Camp coffee, chicory essence, squid ink/Serigrafía con materiales orgánicos: jarabe de sabor a chocolate Hershey, café Camp, esencia de achicoria, tinta de calamar
23 × 31 in. (58.4 × 78.7 cm)

News, Mews, Pews, Brews, Stews & Dues Series: Stews/Serie noticias, maullidos, banquetas, brebajes, guisos y cuotas: guisos, edition/edición 15/125, 1970
Screenprint with organic materials: crushed baked beans, caviar, fresh strawberries, cherry pie filling, mango chutney, tomato paste, crushed daffodils, crushed tulips, leaves/Serigrafía con materiales orgánicos: frijoles cocidos triturados, caviar, fresas frescas, relleno de tarta de cerezas, chutney de mango, pasta de tomate, narcisos triturados, tulipanes triturados, hojas
23 × 31 in. (58.4 × 78.7 cm)

Sunliner: Sunliner #1, edition/edición 37/50, 1995
Aquatint and etching/Aguatinta y grabado
17 × 13 in. (43.2 × 33 cm)

Sunliner: Sunliner #2, edition/edición 37/50, 1995
Aquatint and etching/Aguatinta y grabado
17 × 13 in. (43.2 × 33 cm)

Sunliner: Sunliner #3, edition/edición 37/50, 1995
Aquatint and etching/Aguatinta y grabado
17 × 13 in. (43.2 × 33 cm)

Sunliner: Sunliner #4, edition/edición 37/50, 1995
Aquatint and etching/Aguatinta y grabado
17 × 13 in. (43.2 × 33 cm)

Sunliner: Sunliner #5, edition/edición 37/50, 1995
Aquatint and etching/Aguatinta y grabado
17 × 13 in. (43.2 × 33 cm)

Sunliner: Sunliner #6, edition/edición 37/50, 1995
Aquatint and etching/Aguatinta y grabado
17 × 13 in. (43.2 × 33 cm)

Sunliner: Sunliner #7, edition/edición 37/50, 1995
Aquatint and etching/Aguatinta y grabado
17 × 13 in. (43.2 × 33 cm)

ALISON SAAR (American/estadounidense, b./n. 1956)
Bitter/Sweet/Amargo/Dulce, edition/edición 4/20, 2004
Etching and chine collé, hand-inked tags and string/Aguafuerte y chine collé, etiquetas entintadas a mano y cuerda
28 × 29½ in. (71.1 × 74.9 cm)
© Alison Saar, courtesy of LA Louver, Venice, CA

ANALÍA SABAN (Argentinian/argentina, b./n. 1980)
All works © Analia Saban

GRACIAS GRACIAS GRACIAS THANK YOU THANK YOU THANK YOU Have a Nice Day Plastic Bag/ Bolsa de plástico GRACIAS GRACIAS GRACIAS THANK YOU THANK YOU THANK YOU Que tenga un buen día, edition/edición 7/20, 2016
Mixografia print on handmade paper/Impresión Mixografía en papel hecho a mano
28½ × 20 × 1½ in. (72.4 × 50.8 × 3.8 cm)

Thank You For Your Business Plastic Bag/ Bolsa de plástico Gracias por su compra, edition/edición 7/20, 2016
Mixografia print on handmade paper/Impresión Mixografía en papel hecho a mano
28½ × 20 × 1½ in. (72.4 × 50.8 × 3.8 cm)

JONATHAN SELIGER (American/estadounidense, b./n. 1955)
All works © Images courtesy of the Artist and McClain Gallery, Houston

Pint I/Pinta I, edition/edición 1/15, 2000
Lithograph/Litografía
38⅞ × 11⅝ in. (98.7 × 29.5 cm)

Fresh/Fresco, edition/edición 52/75, 2001
Cotton, pigment, aluminum powder, silkscreen, Mylar/Algodón, pigmento, polvo de aluminio, serigrafía, Mylar
1½ × 4¼ × 4¼ in. (3.8 × 10.8 × 10.8 cm)

LORNA SIMPSON (American/estadounidense, b./n. 1960)
C-Ration/Ración C, edition/edición AP 1/10, 1991
2 silver gelatin prints/Impresión en plata sobre gelatina
Overall: 24¾ × 48 ³/₁₆ in (62.9 × 122.4 cm)
Each image: 18¹³/₁₆ × 42¼ in. (47.8 × 107.3 cm)
© Lorna Simpson
Courtesy the artist and Hauser & Wirth

DONALD SULTAN (American/estadounidense, b./n. 1951)
All works © 2021 Donald Sultan / Artists Rights Society (ARS), New York

Black Lemons/Limones negros, edition/edición 5/14, 1987
Aquatint etching/Grabado al aguatinta
62 × 47⅞ in. (157.5 × 121.6 cm)

Pomegranates/Granadas, edition/edición 13/60, 1990
Aquatint etching/Grabado al aguatinta
47 × 35⅝ in. (119.4 × 90.5 cm)

Pomegranates/Granadas, edition/edición 13/60, 1990
Aquatint etching/Grabado al aguatinta
47 × 35⅝ in. (119.4 × 90.5 cm)

Pomegranates/Granadas, edition/edición 13/60, 1990
Aquatint etching/Grabado al aguatinta
47 × 35⅝ in. (119.4 × 90.5 cm)

Four Lemons: Black Lemon on Silver, July 24, 2018/ Cuatro limones: limón negro sobre plata, 24 de julio, 2018, edition/edición 15/40, 2018
Silkscreen with enamel ink and tar-like texture/ Serigrafía con tinta de esmalte y textura de alquitrán
39 × 39 in. (99.1 × 99.1 cm)

Four Lemons: Black Lemon on White, July 24, 2018/ Cuatro limones: limón negro sobre blanco, 24 de julio, 2018, edition/edición 15/40, 2018
Silkscreen with enamel ink and tar-like texture/ Serigrafía con tinta de esmalte y textura de alquitrán
39 × 39 in. (99.1 × 99.1 cm)

Four Lemons: Black Lemon on Yellow, July 24, 2018/ Cuatro limones: limón negro sobre amarillo, 24 de julio, 2018, edition/edición 15/40, 2018
Silkscreen with enamel ink and tar-like texture/ Serigrafía con tinta de esmalte y textura de alquitrán
39 × 39 in. (99.1 × 99.1 cm)

Four Lemons: Yellow Lemon on Black, July 24, 2018/ Cuatro limones: limón amarillo sobre negro, 24 de julio, 2018, edition/edición 15/40, 2018
Silkscreen with enamel ink and tar-like texture/ Serigrafía con tinta de esmalte y textura de alquitrán
39 × 39 in. (99.1 × 99.1 cm)

WAYNE THIEBAUD (American/ estadounidense, b./n. 1920)
Sandwich/Sándwich, unique proof/prueba única, 1968
Linocut/Linograbado
17½ × 22 in. (44.5 × 55.9 cm)
© 2021 Wayne Thiebaud / Licensed by VAGA at Artists Rights Society (ARS), NY

ANDY WARHOL (American/estadounidense, 1928–1987)
All works © 2021 The Andy Warhol Foundation for the Visual Arts, Inc. / Licensed by Artists Rights Society (ARS), New York

Untitled (Bar Scene)/Sin título (Escena de bar), 1947
Watercolor and ink on paper/Acuarela y tinta sobre papel
7⅛ × 9⅝ in. (18.1 × 24.5 cm)

Untitled (Man and a Woman in a Bar)/Sin título (Hombre y una mujer en un bar), 1947
Watercolor, ink, and graphite on paper/Acuarela, tinta y grafito sobre papel
8⅝ × 9⅝ in. (22 × 24.5 cm)

Banana/Plátano, ca. 1966, edition of approx. 300/ edición de 300 aprox.
Two screenprints on styrene and laminated plastic/ Dos serigrafías sobre estireno y plástico laminado
23¾ × 53¾ in. (60.3 × 136.5 cm)

Campbell's Soup Can (Tomato)/Lata de sopa Campbell (tomate), unlimited edition/edición ilimitada, 1966
Screenprint on paper shopping bag/Serigrafía en una bolsa de papel para la compra
23⅞ × 17 in. (60.6 × 43.2 cm)

Cow 1966/Vaca 1966, 1966
Screenprint on wallpaper mounted to canvas/ Serigrafía sobre papel pintado montado en lienzo
90 × 174 in. (228.6 × 442 cm)

Perrier, 1983
Screenprint/Serigrafía
24⅝ × 34⅛ in. (62.5 × 86.7 cm)

Hamburger (double)/Hamburguesa (doble), 1986
Screenprint/Serigrafía
31⅜ × 24 in. (79.7 × 61 cm)

RACHEL WHITEREAD (British/británica, b./n. 1963)
Squashed/Aplastada, edition/edición 42/42, 2010
Mixografia print on handmade paper/Impresión Mixografía en papel hecho a mano
27 × 37in. (68.58 x 93.98 cm)
© Rachel Whiteread: Courtesy of the artist and Luhring Augustine, New York

SHERRIE WOLF (American/estadounidense, b./n. 1952)
All works © Sherrie Wolf

Artemisia Suite: Bowl of Plums after Artemisia/ Suite Artemisia: Tazón de ciruelas según Artemisia, edition/edición 24/40, 2002
Etching/Grabado
21¾ × 18¼ in. (55.3 × 46.4 cm)

Artemisia Suite: Cherries after Artemisia/Suite Artemisia: Cerezas según Artemisia, edition/edición 24/40, 2002
Etching/Grabado
21¾ × 18¼ in. (55.3 × 46.4 cm)

Artemisia Suite: Three Graces after Rubens/Suite Artemisia: Las Tres Gracias según Rubens, edition/ edición 24/40, 2002
Etching/Grabado
24½ × 18¼ in. (62.2 × 46.4 cm)

Artemisia Suite: Three Pears after Artemisia/Suite Artemisia: Tres peras según Artemisia, edition/ edición 24/40, 2002
Etching/Grabado
21¾ × 18¼ in. (55.3 × 46.4 cm)

Artemisia Suite: Two Pears after Artemisia/Suite Artemisia: Dos peras según Artemisia, edition/ edición 24/40, 2002
Etching/Grabado
21¾ × 18¼ in. (55.3 × 46.4 cm)

Fruit with Rainbow/Fruta con arco iris, 2006
Oil on canvas/Óleo sobre lienzo
40¼ × 60¼ in. (102.2 × 153 cm)

Concert of Birds with Fruit and Pedestal/Concierto de pájaros con fruta y pedestal, 2008
Watercolor on paper/Acuarela sobre papel
29½ × 35 in. (74.9 × 88.9 cm)

Histrionic Beauty Suite: Cherries/Mountain/Suite de belleza histriónica: Cerezas/Montaña, edition/ edición 1/30, 2015
Photogravure and hand-colored etching/ Fotograbado y grabado a mano
19½ × 22¼ in. (49.5 × 56.5 cm)

Histrionic Beauty Suite: Three Pears/Suite de belleza histriónica: Tres peras, edition/edición 1/30, 2015
Photogravure and hand-colored etching/ Fotograbado y grabado a mano
19½ × 25⅛ in. (49.5 × 63.8 cm)

First Harvest/Primera cosecha, 2016
Oil on canvas/Óleo sobre lienzo
60 × 40 in. (152.4 × 101.6 cm)

ALSO PUBLISHED BY THE JORDAN SCHNITZER FAMILY FOUNDATION

Roy Lichtenstein: Prints, 1956–1997 from the Collections of Jordan D. Schnitzer and His Family Foundation

Hardcover, 80 pages
ISBN: 978-0975566213

John Buck: Iconography

Hardcover, 144 pages
ISBN: 978-0910524377

John Baldessari: A Catalogue Raisonné of Prints and Multiples, 1971–2007

Hardcover, 408 pages
ISBN: 978-1555952907

John Baldessari: A Print Retrospective from the Collections of Jordan D. Schnitzer and His Family Foundation

Hardcover, 160 pages
ISBN: 978-1935202103

Letters to Ellsworth

Hardcover, 152 pages
ISBN-13: 978-0984986408

The Prints of Ellsworth Kelly: A Catalogue Raisonné

2 volumes
Hardcover with slipcase,
870 pages
ISBN: 978-0984986422

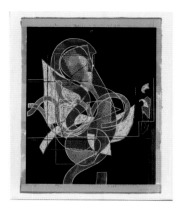

Frank Stella: Prints: A Catalogue Raisonné

Hardcover, 432 pages
ISBN: 978-0692587072

Andy Warhol Prints

Hardcover, 184 pages
ISBN: 978-0692764473

Beyond Mammy, Jezebel & Sapphire: Reclaiming Images of Black Women

Hardcover, 80 pages
ISBN: 978-0692803172

Amazing! Mel Bochner Prints from the Collections of Jordan D. Schnitzer and His Family Foundation

Hardcover, 256 pages
ISBN: 978-1732321205

Witness: Themes of Social Justice in Contemporary Printmaking and Photography from the Collections of Jordan D. Schnitzer and His Family Foundation

Hardcover, 160 pages
ISBN 978-0-692-16298-9

Mirror, Mirror: The Prints of Alison Saar from the Collections of Jordan D. Schnitzer and His Family Foundation

Hardcover, 128 pages
ISBN: 978-1-7323212-1-2

Global Asias: Contemporary Asian and Asian American Art from the Collections of Jordan D. Schnitzer and His Family Foundation

Hardcover, 104 pages
ISBN: 978-1-7323212-3-6

Published by the Jordan Schnitzer Family Foundation in conjunction with the exhibition
Art of Food: From the Collections of Jordan D. Schnitzer and His Family Foundation
University of Arizona Museum of Art, Tucson, AZ: October 24, 2021–March 20,2022

© 2021 by the Jordan Schnitzer Family Foundation, Portland, OR

Texts © the authors

Translation by Valentina Sarmiento Cruz and Jaime Fatas

Designed by Phil Kovacevich

Edited by Carolyn Vaughan

Proofread in English by Carrie Wicks

Proofread in Spanish by Valentina Sarmiento Cruz

All measurements are given in inches followed by centimeters. Height proceeds width.

Front cover: Andy Warhol, *Banana, ca.* 1966, screenprint. © 2021 The Andy Warhol Foundation for the Visual Arts, Inc. / Licensed by Artists Rights Society (ARS), New York

Frontispiece: Sherrie Wolf, *First Harvest* (detail), 2016, oil on canvas. © Sherrie Wolf

Back cover: Chris Antemann, *Fruit Pyramid*, 2014, Meissen porcelain. © Chris Antemann in Collaboration with MEISSEN

Photography Credits

Courtesy of Gemini G.E.L.: pp. 30, 73

Strode Photographic, LLC: pp. 10, 27, 34, 49, 54–59, 60 (right image), 65, 68–69, 81, (lower right image), 98–99, 101, 109, 114–15, 123.

Aaron Wessling Photography: pp. 2, 6, 9, 13-14, 18, 21–26, 28–29, 31–33, 35, 37, 39, 43–48, 53, 60 (left image), 61, 66–67, 74–77, 79, 82–83, 86–89, 91 (upper left, upper right, and lower left images), 92–95, 100, 103–5, 108, 110–13, 117–22.

ISBN: 978-1-7323212-4-3

Library of Congress Control Number: 2021915433

Printed in the United States

Distributed by D.A.P.
Distributed Art Publishers
155 Sixth Avenue
2nd Floor
New York, NY 10013
artbook.com